MW00612925

THE
JEFFERSON HIGHWAY
in
OKLAHOMA

The Historic Osage Trace

JONITA MULLINS

Foreword by Glenn E. Smith

THE
History
PRESS

Published by The History Press
Charleston, SC
www.historypress.net

Front cover, top: This tree-lined boulevard took travelers along the Jefferson Highway through the heart of Muskogee, once the unofficial capital of Indian Territory. *Glenn E. Smith collection.*

First published 2016

Manufactured in the United States

ISBN 978.1.46713.633.4

Library of Congress Control Number: 2016947529

CONTENTS

FOREWORD

The Jefferson Highway was an important asset to the new state of Oklahoma. The Jefferson Highway Association was formed in New Orleans, and a large group of businessmen from Oklahoma made the trip to attend that important meeting.

Oklahoma became the forty-sixth state in November 1907, and eight years later, in November 1915, a group of Good Road enthusiasts made a bid to obtain an International Highway for Oklahoma.

When the first organizational meeting of the Jefferson Highway Association was held in New Orleans on November 15–16, 1915, it expected to attract about fifty delegates, but over six times that number attended. In fact, more than fifty delegates showed up from the new state of Oklahoma alone. This first meeting showed how much rivalry there was between the states, as all of them wanted the Jefferson Highway to run through their cities.

The *Muskogee Times-Democrat* newspaper dated November 6, 1915, contained the following statement about the Jefferson Highway:

> *Believing an auto road—which in time will be a cement thoroughfare permanent enough to move armies over—will be worth more to Muskogee than another railroad, the delegates will join a special train leaving Parsons, Kansas with about 100 Kansans aboard, here the evening of November 12. Vinita, Dr. Bagby said, will send four delegates—other towns in eastern Oklahoma will send from one to a half-dozen, and Muskogee, with over 40,000 population, ought to send 40 men if they can be found willing*

to neglect their personal business long enough to go down and help out vote Missouri and Arkansas.

D.N. Fink of Muskogee became the leader of the Oklahoma delegation and, along with other representatives, won the vote to route the highway through Texas to Durant, Oklahoma, and then north through McAlester, Muskogee and Vinita to the Kansas and Missouri state lines. Mr. Fink was popular with all delegates and was elected vice-president at this same meeting.

This historic road through Oklahoma, today known as Highway 69, has a long history of travel by many people. Jonita Mullins has recorded the progression of this long-ago Native American path to the busy modern highway it is today.

GLENN E. SMITH
Muskogee, Oklahoma
President, Jefferson Highway Association, 2014–2016

INTRODUCTION

In the distant mists of time, the place we know as Oklahoma was a wilderness teeming with a vast array of flora and fauna. As many as eleven distinct eco-regions of the surrounding states seep into this one geographical spot, making it an inviting habitat for hundreds of species of plants and animals.

Its central location on the North American continent also made Oklahoma a crossroads even before human habitation. With the passage of time, the tread of thousands of feet and the turn of thousands of wheels created the first true roads passing over and through a beautiful region of the American West.

Those trails of yesterday have become the superhighways of today, carrying travelers along the same routes our ancestors followed. We travel for the same reasons—to explore, hunt, trade, visit and mourn just as we have always done. We follow the same paths, sometimes without even realizing who has traveled this way before us.

One such modern highway crossing Oklahoma is Route 69, also known as the Jefferson Highway. As a paved highway, it began in 1915, but as a much-traveled road, it stretches back for hundreds and perhaps even thousands of years. The earliest written references to it called it the Osage Trace.

But even before the Osages traveled over this road, it was likely used by earlier people who inhabited the region. And before that, it may well have been the pathway of both woodland and prairie creatures, letting their instincts lead them to the best grazing lands, a salt source, a watering hole or a place to pounce on unsuspecting prey.

INTRODUCTION

As historian Grant Foreman once observed of this ancient road, the engineers of today could not calculate a better route than those instincts of both human and beast that traveled this way before us. From trail to road to railroad to highway, this old road is still the best way to cross through Oklahoma. A journey down the Jefferson Highway today recalls some of Oklahoma's most important history and celebrates some of our most interesting places and people.

ANCIENT TRAILS

THE BUFFALO TRAIL

The ancient trails crossing the area throbbed with the hoof beats of vast herds of bison, elk and deer. In southern Oklahoma, on the Jefferson Highway, the town of Caddo celebrates the fact that it sits on an old buffalo trail.

The seasonal migration of this giant of the prairie was keenly important to the health of the ecosystem. The trails and wallows they carved into the land remained even after their numbers were decimated. The bison provided the first paths for hunters to follow.

The migratory trail of the buffalo was beaten hard, and the ground was eaten clean of tree seedlings and scrubby growth, leaving a healthy prairie. The wallows were formed when a more than 1,900-pound bison would take a dust bath. These impressions in the landscape became useful

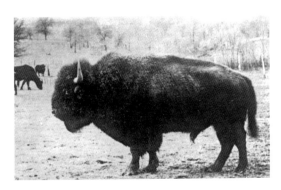

Great bison once ruled the prairie in massive numbers and crossed Oklahoma during their annual migration across the plains. *Oklahoma Historical Society.*

catch basins for rain in the hot summers and provided watering holes for other prairie creatures.

So it is not unreasonable to claim that the bedrock beginning of the Jefferson Highway in Oklahoma was the work of the great bison. An animal so much associated with the American West, the buffalo and its trails across the plains started us on the road we travel today.

EARLY TRAILS OF THE FIRST PEOPLE

The area of Oklahoma traversed by the Jefferson Highway was the hunting grounds of a very early people known as the Calf Creeks, who left their spear points behind as evidence of the hunt. One such point was found in an ancient bison skull in the Arkansas River, which the Jefferson crosses at Muskogee. The Calf Creek people were so named because the first spear point associated with them was found in Calf Creek Cave in Searcy County, Arkansas.

It is believed that the Calf Creeks were a nomadic tribe moving around the Arkansas River basin, following the migration of the bison. They likely walked along that old buffalo trail in search of the king of the prairie. Their spear points were large and unique. The stoneworkers would heat the rock before "knapping" it. Knapping is the process of flaking off the edges of a flat rock to create a razor-like sharpness. Heating the rock made it easier to break, and the Calf Creek people seem to have been the first to develop this process.

The Calf Creek people left behind campsites along the trails, yet very little is known about them. They were in this region for a relatively short period of time and then faded from view.

A more recent people to inhabit the area were the Mississippian Mound Builders who lived along the riverbanks in eastern Oklahoma. Their mounds are found along the Grand River in Mayes County, along the Verdigris River in Wagoner County and the Arkansas River in Muskogee County. Some of these old burial and temple mounds are still visible from the Jefferson Highway.

Unlike previous cultures that relied primarily on hunting and gathering for food, the Mound Builders were also farmers. They planted corn, squash, pumpkins, beans and sunflowers in the rich river bottom lands where they lived. They developed new methods of storing food and were involved in trade with other native peoples all across North America.

By traveling the old trails that crossed the continent, trade among the various first nations was surprisingly extensive. Materials found in the old mounds in Oklahoma came from distant locations brought over the old trade trails.

The mounds were used as burial sites and also for religious ceremonies. Mounds might also have served as compass points and calendars or as lookout points, helpful in tracking the movement of game or of rival tribes. Some mounds served as lookout points long after their original builders were gone. In Wagoner County, west of the Jefferson Highway, a site called Blue Mound was used by troops as a lookout location during the Civil War.

The Mound Builders in Oklahoma were of Kadohadacho stock and were ancestors of the Caddo and Wichita tribes of today. Mound Builders who settled east of the Mississippi River were ancestors of today's Muscogee (Creek) Nation. The Caddo, Wichita and Creek Nations all have their headquarters today in Oklahoma. The Jefferson Highway passes through the Creek Nation.

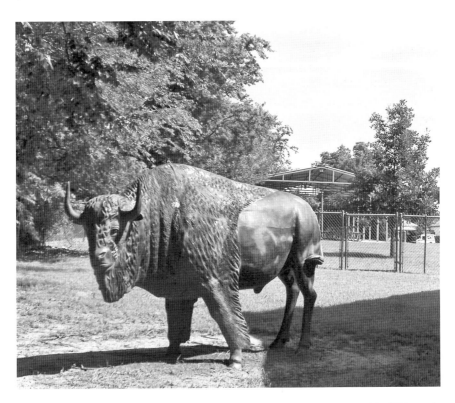

Statues of buffalo are common in Oklahoma, celebrating the king of the prairie. This one is just off old Highway 69 in Old Town McAlester. *Author's collection.*

The town of Caddo, on that old buffalo trail, was named for the Kadohadacho people who, before European contact, lived and hunted along the Red River. Members of the Caddo and Wichita tribes were dominant in the region crossed by the old buffalo and trade trails well into the mid-1700s.

OSAGE TRACE

The Wichita and Caddo were gradually pushed southward by the more aggressive Osage tribe. Early records about the Osages show them living in large, permanent villages along the Osage River in what is now Missouri. The Osages depended on the buffalo but were also farmers. As the French established trading posts along the Mississippi River, the Osages became astute traders as well.

In time, the Osages became professional hunters, depending more and more on their trade with Europeans and Americans for their existence. But game grew scarce in their traditional homelands, so they moved farther west and south in hunting expeditions. Their hunting territory eventually encompassed parts of Missouri, Arkansas, Kansas and Oklahoma.

This led the Osages into a region of Oklahoma known as the Three Forks. Here, the Verdigris and Grand (Neosho) Rivers flow into the Arkansas River within a mile of each other. Salt springs were abundant in this region and may have been another reason why the Osages traveled frequently into the area.

Because of the abundance of water and salt, the area also attracted an abundance of game. By the mid-1700s, the Osages were spending much of their time in the Three Forks region, camping between the Verdigris and Grand Rivers. Their hunting trail between the Osage River and the Arkansas River at Three Forks became one of the best-developed trails in the region and was known as the Osage Trace.

In the late 1700s, the Osages were led by Chiefs Pawhuska, Black Dog, Cashesegra and Claremont. Each had established villages within their hunting territory. Gradually, all the chiefs but Pawhuska moved their villages into what was then western Arkansas Territory but today is Oklahoma. The Osage Trace developed several branches among these villages and along the game trails they followed in their hunting forays.

Cashesegra (called Big Track in historical records) led a young and aggressive band of the Osages. Sometime between 1780 and 1802,

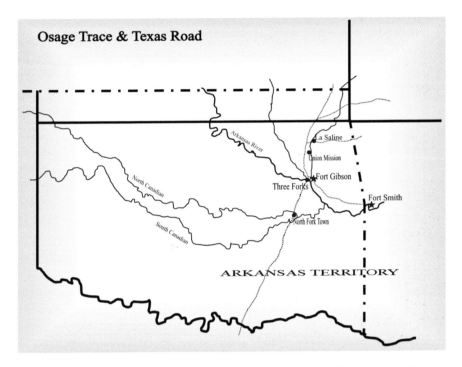

The early native trails through Oklahoma became known as the Osage Trace. *Author's collection.*

Cashesegra led his group to settle permanently in the Three Forks area. Their village was located across the river from where Fort Gibson would later be built.

Another large band of Osages was led by Black Dog. Accounts of Black Dog show he was a skilled and progressive leader. One of his achievements was to create the Black Dog Trail from today's Baxter Springs, Kansas, into Oklahoma. Around 1800, this trail, part of the larger Osage Trace, was so well traveled and maintained that it would be called the first improved road in either Kansas or Oklahoma.

Black Dog's group built ramps down to the fords across streams and cleared the road of all brush and large rocks. As some of the most accomplished horsemen on the prairie, the Osages needed a road that was more than a mere footpath. They created a broad enough thoroughfare that eight horses could pass along it abreast.

In about 1803, at the time of the Louisiana Purchase, Black Dog settled his band permanently in Arkansas Territory near the Verdigris River. Soon afterward, Claremont also settled in the area among a grouping of ancient mounds that later became known as Claremore Mound.

As the region moved from French to American control, there were over one thousand Osages living in villages along the various branches of the Osage Trace. Later towns would develop at many of these sites, and the Osage Trace gave birth to several highways that today connect those towns.

THE FUR TRADE

THE PURCHASE

In April 1803, President Thomas Jefferson's administration began negotiations with Napoleon of France to purchase 800,000 square miles of land extending from the Mississippi River to the Rocky Mountains. The cost was $15 million, roughly four cents per acre.

Fifteen states, including Oklahoma, were part of the Louisiana Purchase, and it is through several of these states that the Jefferson Highway runs. The Osage Trace in Missouri, Arkansas, Kansas and Oklahoma would form the central portion of the Jefferson Highway in the territory that our third president purchased. Early promoters of the highway gave it the name Jefferson because it would run through the land this president secured for the United States.

The Louisiana Territory was a largely unexplored and unmapped area, and its western boundary wasn't even clearly defined. The southern boundary was the Red River, separating Louisiana from Texas, then held by the Spanish.

Jefferson had set out to purchase only New Orleans in order to keep trade and traffic on the Mississippi free and open. When Napoleon offered the whole of Louisiana Territory, Jefferson's envoy, James Monroe, jumped at the opportunity. The English version of the treaty was signed on May 2, 1803. With the stroke of a pen, the size of the United States was doubled.

Even before the purchase had been approved by Congress, Jefferson was preparing to send explorers into this uncharted territory. The most famous

of these explorations was the Lewis and Clark Expedition that searched the northern reaches of the territory for an all-water route across the continent.

When Lewis and Clark returned from their two-year journey, they submitted a report to President Jefferson on Louisiana Territory. Included in this report was a recommendation of a good location for a fur trading post. They referred to the Three Forks area on the Arkansas, about six hundred miles from its junction with the Mississippi.

How did Lewis and Clark know about the Three Forks? They journeyed nowhere near Oklahoma on their famous expedition. Though it's undocumented, most historians believe the explorers learned about the Three Forks from Auguste Chouteau, who outfitted the men from his trading post at St. Louis. The Chouteau family had long traded with the Osages, whose improved trail led to this well-known geographical location.

It wasn't long after the Lewis and Clark Expedition that trading posts sprang up all along the Three Rivers. As a part of the historic Louisiana Purchase of 1803, the Osage Trace corridor, within this vast piece of real estate, was among the first to be developed by Americans.

THE FUR TRADE

The Osage Trace provided enterprising fur traders access to the Osage villages where they could do business. Both French and American traders came from posts along the Mississippi and Red Rivers to barter for the harvest of hides and furs taken in the hunt.

Probably no family profited more from trade with the Osages than the Chouteaus, who helped to establish St. Louis in 1764. Auguste Chouteau, as a thirteen-year-old, had been part of a corps of men sent from New Orleans to establish a trading post farther north on the Mississippi.

The Chouteaus had turned their trade with the Osages in Missouri into one of the largest fur trading outfits in America, rivaling that of John Jacob Astor. And along the way, they had established themselves as experts in Indian affairs. French, Spanish and American authorities all relied on the Chouteaus for assistance with Indian relations.

Jean Pierre Chouteau, the younger brother of Auguste, is credited with expanding the family's interests well south and west of St. Louis into today's Oklahoma, beginning in 1796. With Osage guides, Jean Pierre explored the region, following the Osage road in a southwesterly direction. When

Salina's Ferry Street recalls its earliest settlement, when the Chouteau family operated a ferry over the Grand River to the Osage Trace. *Salina Chamber of Commerce.*

reaching a river that the Osages called the *Neosho* (meaning "clear water"), he declared it "grand!" and determined to find a location along its banks for a new trading post.

The Osage Trace, in more than one of its branches, followed the route of the Grand River to its juncture with the Arkansas at Three Forks. Chouteau established a trading post at a location where the main branch of the trace, the Grand River and a secondary trail from northwest Arkansas all joined together. There was a very large salt spring here, and Chouteau gave his post the name La Saline.

A ferry operated by Chouteau's employees or slaves crossed the Grand River at La Saline, connecting the two Osage trails. Today, a bridge at the town of Salina takes Highway 20 across the river and its reservoir Lake Hudson.

Little remains of La Saline except one very old paradise tree said to have been imported from France for the Chouteau residence. The old salt spring is just a ghost of its former productive self.

But in Salina, the street leading to the bridge crossing the Grand River is called Ferry Street, a reminder of what Chouteau built here and why the town of Salina exists in this place along the Osage Trace. Highway 20 then passes westward to meet the Jefferson Highway and continues on to Claremore, where the villages of Black Dog and Claremont were located.

The Chouteaus are credited with persuading the Osages under Black Dog, Cashesegra and Claremont to move to the region of the Three Rivers around 1800. Spanish authorities at New Orleans had granted a license to another trader named Manuel Lisa, putting the Chouteau monopoly in peril. To solve the problem, Chouteau and most of the Osages moved away from Missouri, where Lisa was operating.

As Spanish and French control of the region ended, the Chouteau family made the decision to "be good Americans" and make the most of the new conditions on the prairie. The Chouteaus not only outfitted the Lewis and Clark Corps of Discovery, but they likely also started Zebulon Pike on his way when his expedition left St. Louis in 1806 in search of the source of the Arkansas River.

Pike's corps arrived at the Big Bend of the Arkansas in western Kansas in late fall. While Pike continued up the river, he dispatched his second in command, James Wilkinson, to travel down the Arkansas.

Wilkinson and a party of five soldiers followed the Arkansas River southeast, traveling in pirogues (hollowed-out logs) cut from cottonwood trees. Wilkinson's journal of this exploration is the first American account of northeastern Oklahoma and the Osage Trace. He reported passing several Osage villages, as well as a number of Cherokee and Choctaw hunting parties.

Travel down the Arkansas was slow as the weather turned colder. On occasion, the explorers would have to chop through layers of ice formed on the river. Rain and snow hampered them as well. At one point, a pirogue turned over in the icy water and dumped much of their supplies. Had it not been for a friendly band of Osages resupplying the Americans, they might not have survived the journey.

On December 23, 1806, Wilkinson's party rested at the village of Big Track, located between the Verdigris and Grand Rivers at Three Forks. Wilkinson found the Osages eager to trade with the Americans, and they asked that a trading post be established in the area.

As Wilkinson's group continued down the Arkansas, they met Joseph Bogey traveling upriver from Arkansas Post, a settlement at the mouth of the Arkansas River. Bogey, a Frenchman who had been trading along the Arkansas for a number of years, had secured a license to trade with the Osages in the Three Forks area.

With a large boat loaded with goods for trade and a crew of twelve men, Bogey was braving the late December cold to travel to the mouth of the Verdigris. He entered this river and found a deep stretch of still waters below the Verdigris Falls near the present town of Okay and very near the Osage Trace. Here, he built his trading post at a spot where his flatboats could land.

Bogey's post was the first at Three Forks and followed only the Chouteaus in establishing a presence in Oklahoma. Within the next ten years, another dozen traders would also follow the Chouteaus' lead into the Three Forks

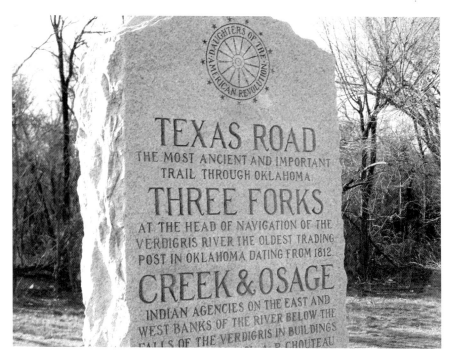

This historical marker, placed in the 1930s, notes the location of the first fur trading post at Three Forks. Author's collection.

area, making it one of the most important fur trading centers west of the Mississippi. By 1812, both banks of the Verdigris River near its falls were lined with trading posts.

Jean Pierre Chouteau can be called the father of the fur trade in Oklahoma, having been the first to utilize the Osage Trace to transport furs back to St. Louis. But his son Auguste Pierre Chouteau truly built the family empire in Oklahoma.

After graduating from the Military Academy at West Point, the younger Chouteau returned to the frontier and around 1819 set about to expand on what Jean Pierre had begun. Colonel A.P. Chouteau took responsibility for the family's fur trade at La Saline and in the Three Forks area.

By the time Fort Gibson was established in 1824, Chouteau had taken a small trading post on the Verdigris River and built it into one of the largest on the western frontier. He employed a large number of men, of all races, to work in his fur factory and his shipyard.

The Osages and other tribes brought their peltries to the Chouteau posts over the trace. If Black Dog built the first road, Chouteau put traffic on it

by creating a lucrative business for both his family and the Indians who were his loyal trade partners.

Chouteau's employees built boats on which he shipped his peltries to New Orleans. He hired skilled river men to navigate the tricky Mississippi, and upon reaching their destination, they would sell the furs and the wood used to build the boats. Then they would load a keelboat with supplies and trade goods and return to Three Forks.

Besides being regarded as an astute businessman, Colonel Chouteau was also a recognized authority in Indian Territory. Until his death in 1838, Chouteau was frequently involved in treaty negotiations among various Indian tribes.

The military at Fort Gibson welcomed his visits and would often consult with him on matters relating to Native Americans. Officials in Washington respected his judgment and often deferred decisions on Indian affairs to him.

It is not an exaggeration to say that the Chouteaus were one of the most important families on the American frontier. A town on the Jefferson Highway would later take the name of Chouteau in recognition of the significant contribution this family made to the road and the state.

MAYHEM, MISSIONS, MIGRATION

MAYHEM

In the transitional years from French to American control of the Louisiana Territory, the Osages remained the dominant tribe in the fur trade region of the Three Forks and the Osage Trace. But conditions began to change, and by 1814, following the end of the War of 1812, the Osages found themselves challenged on their hunting grounds.

In Washington, a long-considered policy of moving Indian tribes west was gaining momentum. Jefferson's purchase of the Louisiana Territory had made this a viable possibility. The Creek and Seminole Wars in Georgia and Florida further stirred American sentiment toward Indian removal.

By persuasion or outright attack, state governments were pressing the tribes of the southeastern United States to move to the vast prairie. From many explorations of the region, it was known to have an abundance of game but was commonly considered an area unsuitable for farming. This made it less appealing for American settlement.

In response to this pressure, a migration of around two thousand Cherokees had begun in 1812. These Native Americans left lands in the Blue Ridge Mountains for lands in the Ozarks. They settled along the Arkansas River, roughly halfway between the Three Forks and the Mississippi.

From their new homes, they would join other Cherokees in the region in buffalo hunts during the fall and spring migration, following the herds along the old trails. But the Osages considered this their territory and were not

opposed to using force to protect their claim. Travel over the Osage Trace became dangerous, and hunting parties often turned into war parties as the two tribes clashed.

As the animosity between the Osages and their new neighbors grew, so did fear among the few American settlers of Arkansas Territory. They clamored for protection and for a treaty of peace between the two tribes.

As early as 1814, Cherokee agent William Lovely had recommended to the government that a fort be built somewhere along the Osage-Cherokee boundary. Such a military presence, he hoped, would curb fighting between the two tribes and would also discourage non-Indian settlement on lands reserved for the Indians.

In 1817, Secretary of War Richard Graham ordered General Andrew Jackson to build such an army post. Jackson, in turn, passed the orders to General Thomas Smith, who dispatched Major William Bradford and his rifle regiment into the region.

Bradford sent Major Stephen Long, a topographical engineer, and a small contingent of soldiers to scout the best location for the fort. Major Long chose Belle Point because of its commanding view of the Arkansas River

Originally, Fort Smith sat in the center of Arkansas Territory but later marked the boundary between Arkansas and Indian Territory. *Author's collection.*

where it meets the Poteau River. Bradford and his remaining men arrived to begin construction of Fort Smith.

It was only a few years later that Fort Smith's second commander, Colonel Matthew Arbuckle, deemed the fort too far removed from the center of Osage settlement and from any passable roads.

The decision to establish a new fort farther west was firmly settled in November 1823, after Osage warrior Mad Buffalo led an attack on Cherokees in Arkansas Territory that resulted in the death of four settlers. Fort Smith was proving to be too far removed from the Osage settlements on the Three Rivers to be an effective deterrent of tribal clashes.

With men from the Seventh Infantry, Arbuckle traveled by flatboat up the Arkansas River from Fort Smith. Arriving in April 1824, they found that the best landing sites on the Verdigris were already claimed by the several fur trading outfits operating at the Three Forks.

So Arbuckle and his men headed up the Grand River and found a rock ledge about three miles above its juncture with the Arkansas. This ledge, which still exists today, formed a natural landing point for the boats that would supply the fort with men and materials for years to come. Soon, a branch of the Osage Trace veered to the west at Three Forks to cross the Grand River to this new fort.

When Fort Gibson was established, it was the westernmost fort in American territory. It was part of a chain of forts that ran from Fort Snelling in Missouri to Fort Jesup in Louisiana and included Fort Towson, built in Indian Territory. But Fort Gibson was considered pivotal in keeping peace among the Indians and at times garrisoned more soldiers than all the other frontier forts combined.

The soldiers of the Seventh Infantry began the daunting task of clearing the land for the fort. A thick canebrake lined the shores of all three rivers and had to be either hacked down with machetes or burned off. Enormous trees were felled for logs to build a stockade and living quarters for the soldiers. It wasn't until 1826 that the fort was fully completed.

Fort Gibson played an important role in the settlement and development of Indian Territory. It served as the base of operation for many expeditions to the western tribes. Soldiers were sent from its walls to build many of the other forts in the territory. Many important meetings between the government and area tribes were held here because the rivers and the Osage Trace gave it great accessibility.

Fort Gibson became a primary location along the Osage Trace and remained so for years, even as the road itself went through many changes.

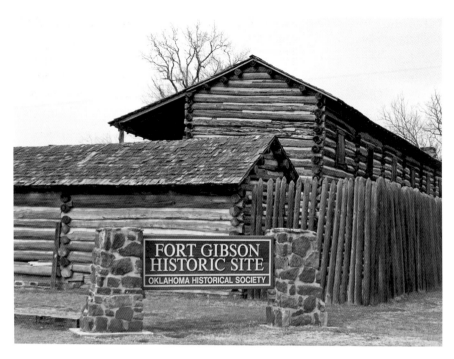

The stockade of Fort Gibson was rebuilt in 1934 and continues to draw visitors as it did in the early 1800s. *Author's collection.*

Though the town of Fort Gibson today does not sit on the Jefferson Highway, historically the post was the road's most significant destination.

In part because of ̶̶̶̶̶ ̶̶̶̶̶?. Chouteau purchased a trading post across the river and us̶̶̶̶̶ ̶̶̶̶̶ ̶̶̶y to the Osages. Between the fort and this post, the governm̶̶̶̶̶ ̶̶̶̶̶ ̶̶̶̶̶ith the tribe was more efficiently and effectively managed, ̶̶̶̶̶ ̶̶̶̶̶ ̶̶̶se of peace came to the prairie. It was safer to travel throug̶̶̶̶̶ ̶̶̶̶̶ ̶̶̶̶̶oon the road would fill with thousands more wayfarers.

MISSIONS

Another effort to bring peace to the prairie was found in the work of early Christian missions located along the Osage Trace. In 1820, the United Foreign Mission Society established three missions in the Osage and Cherokee lands of western Arkansas Territory and Missouri.

Dwight Mission was placed near the town of Dardanelle among the Western Cherokees. Harmony Mission was built at the northern reach of the Osage Trace near the village of Chief Pawhuska.

The third mission was named Union Mission and was built between the villages of Claremont and Big Track. This mission also sat between the clear Grand River and the Osage Trace, making it another important destination point among travelers along the road. It was located near the present town of Mazie, where the Jefferson Highway still closely follows the old route of the Indian trail.

An advance party of men, led by the director Reverend Epaphras Chapman, arrived at the mission site in November 1820. They brought two flatboats of supplies up the Grand River. They built their mission from pine logs, harvested from "the spavinaw" (a corruption of the French word for a stand of young trees). They had to float the logs down the Grand River from the pine grove near the present town of Spavinaw, which sits on Highway 20 and the Arkansas branch of the Osage Trace.

The missionaries had been aided in securing the land by a fur trader named Nathaniel Pryor, who operated a post at Three Forks. Like A.P. Chouteau, Pryor had married an Osage woman, spoke the language and sometimes acted as a sub agent to the tribe.

Pryor had located his own home along a creek that ran north of the mission and close to Chouteau's home, La Saline. This creek eventually gained the name of Pryor's Creek, and a town, called Pryor Creek or sometimes simply Pryor, later sprang up on the highway.

Nathaniel Pryor had an interesting history himself, and his association with the Jefferson Highway adds to the road's richness. Pryor had served as a sergeant with the Lewis and Clark Expedition and must have surely made the acquaintance of the Chouteau family. After the Corps of Discovery returned from the Pacific coast, Pryor, along with all the corps, was heralded as a hero.

Pryor continued in military service as an ensign in the First U.S. Infantry. He served under General Andrew Jackson at the Battle of New Orleans in the War of 1812. He rose to the rank of captain in the Forty-Fourth Infantry and for the remainder of his life was addressed as Captain Pryor.

In 1816, Pryor entered business with a fur trader named Samuel Richards at the French American settlement of Arkansas Post, located near the mouth of the Arkansas River. He remained there for a few years, then obtained a license to trade with the Osages at a post on the Verdigris River at the Three Forks along the Osage Trace.

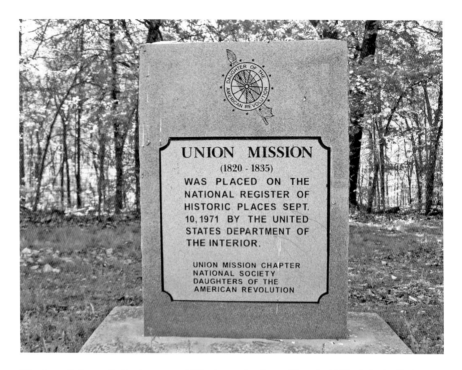

The first mission and school were established near the Osage Trace in 1820. *Author's collection.*

Here, Captain Pryor enjoyed good trade relations with Chief Claremont and his band of Osages. Pryor quickly established himself as a highly respected leader among the American traders who were beginning to populate the Three Forks area. His experience with Lewis and Clark had been valuable training for surviving the wilderness and dealing with the native people.

It was largely due to Pryor's influence that Chief Claremont allowed Union Mission to be established within his territory. The Osages themselves showed little interest in the school offered at the mission, which was the first one in Oklahoma. But the missionaries labored valiantly for nearly twenty years at their outpost on a quickly expanding highway through the region.

From their location, Union Mission workers witnessed some of Oklahoma's most interesting history. Today, just off Highway 69, all that remains of the mission is a small cemetery that is lovingly maintained by the Union Mission Chapter of the Daughters of the American Revolution. There is a haunting beauty in this remote burial ground with simple metal markers over the graves. This cemetery holds the oldest known and marked graves in the state.

Three later missions also sat on or near the Osage Trace. Ebenezer Mission was an early effort to work among the newly arriving Creeks. The Baptist Church established by this mission in 1832 was the first Baptist congregation in Oklahoma. This church still exists today as Fountain Baptist at a location just east of Highway 69, near Muskogee.

Tullahassee Mission to the Muscogee (Creek) Nation gave rise to the present town of Tullahassee in Wagoner County. Tullahassee Mission is associated with some of the Creek Nation's most prominent historical figures, such as Congresswoman Alice Robertson and Chief Pleasant Porter.

Farther south, Armstrong Academy served the Choctaw Nation near the present town of Armstrong in Bryan County. Built on the manual labor theory of education, the students learned farming and home management skills, as well as the three "*R*s."

MIGRATION

By the late 1820s, traffic along the Osage Trace had seen a tremendous uptick as a new kind of migration began to take place. No longer a trail for buffalo, the road was now filled with dozens, then hundreds and eventually thousands of ox-drawn covered wagons heading south to Texas.

This first wave of Manifest Destiny into Mexican-held Texas would give the thoroughfare a new name. It would be called the Texas Road. The history of Oklahoma is filled with early references to the road, as travelers of distinction made their way along it.

For many such travelers, the attraction to migrate west was land. Mexico had gained its independence from Spain in 1821 and wanted to encourage colonization. Large grants of land to empresarios such as Stephen Austin opened a floodgate of immigration. Those land-seekers coming from Arkansas, Missouri and the Midwest followed the Texas Road through the Indian nations. Austin's colony alone settled about 1,500 families around San Antonio.

This first wave of western settlers changed the road and established it as an important route through what would soon be called the Indian Territory. The metal-rimmed wheels of the covered wagons dug deep into the earth. Once trampled smooth by many hooves, the road now became scarred and rutted.

When the ruts were worn so deep as to be dangerous, the travelers would simply move their wagons over a little farther. Soon, the road cut a wide swath through lands being offered to the southeastern Indian tribes. Smaller

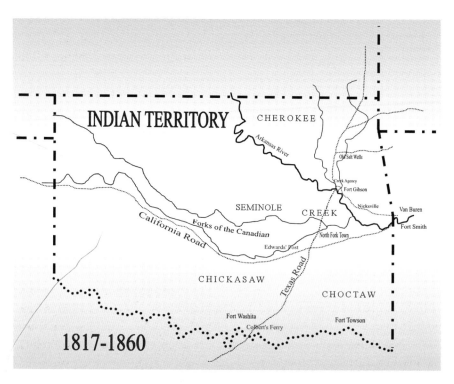

The California Road had its various branches just as the Texas Road did, but the main route followed the Canadian River across Indian Territory. *Author's collection.*

roads and trails fed into it to make the Texas Road one of Oklahoma's most traveled thoroughfares both then and now.

Another major migration westward was the California gold rush that commenced in 1849. As soon as word reached the eastern states that there was gold to be mined in California, routes westward saw immediate traffic. One of the best routes ran through the Indian Territory from Fort Smith and Van Buren, Arkansas. It quickly came to be called the California Road and followed trails marked by earlier explorations.

The California Road followed the Arkansas River out of Fort Smith to its juncture with the Canadian River. This river junction became another trading area, and a community known as North Fork Town (for the North Fork of the Canadian River) developed. Like the Osage Trace before it, several branches of the California Road were developed because wagon train leaders had differing opinions on the best route.

Generally, the road to gold followed the Canadian River to the Texas Panhandle and then on to Santa Fe. As many as twenty thousand migrant

gold miners traveled through Indian Territory in 1849 alone. Their journey of two thousand miles would take many weeks to complete. The southern route to California passed through Indian lands and was not without its hazards. However, it enjoyed a more temperate climate than more northern routes and was the best route for gold seekers from the southern United States.

The California Road and the Texas Road crossed south of North Fork Town, and this juncture created additional points for settlement and trade. One town was known as Bucklucksy, a Choctaw town that today lies under the Eufaula Lake. Another was the town of Perryville, named for Choctaw emigrant James Perry, who had settled in the area in 1838. For a time, Perryville served as the capital of the Choctaw Nation and county seat of Tobusky County in the nation. Both of these towns would eventually form today's town of McAlester.

Another branch of the California Road turned south in the Choctaw Nation, joining the Texas Road to run southward along it and cross the Red River at a location known as Colbert's Ferry. Once in Texas, the route turned westward again toward Santa Fe. This route was only 1,700 miles and became a preferred road for later stage travel and military movements.

Because of the treaties signed with the various Indian tribes, the land crossed by the Texas Road and California Road was officially off limits to non-Indian settlement. This fact was only loosely enforced, but it did serve to make the two roads only a means to pass through Indian Territory, and multiple thousands of western migrants did so from 1822 to the onset of the American Civil War.

4

INDIAN REMOVALS

THE INDIAN REMOVALS

While Oklahoma's history is filled with the dramatic and poignant story of the removal of the Five Civilized Tribes, that is not the beginning of Native American migration to and through the state. Even before European settlement of the American continents, native tribes would often feel pressured to move to new localities.

Sometimes this pressure arose from natural conditions, such as a flood or a prolonged drought. At other times, the pressure came from a rival tribe challenging them for the right to live or hunt in a certain area. Thus, of the number of tribes that are considered native to Oklahoma—such as the Caddos, Comanches, Wichitas and Kiowas—all migrated along the old trails to this area long before the Spanish and French were sending exploration parties into Oklahoma.

The Osages pushed these tribes to the south and west and enjoyed dominance in the region long enough to establish the road that would bear their name. The Western Cherokees were settled in the area of the trace by 1825, with additional tribal members arriving through the next several years.

In 1820, the long-considered government policy of removing the Indians who resided east of the Mississippi was finally put into action. In that year, an agreement with the Choctaws of Mississippi, known as the Treaty of Doak's Stand, offered this tribe land in western Arkansas Territory between the Red and Canadian Rivers, along the southern section of the Texas Road.

A few individual Choctaws may have moved as a result of this treaty, but the tribe as a whole did not. Tribal members were deeply reluctant to leave long-held homelands, where they had hunted and farmed for many generations and where their ancestors were buried. But pressure on the tribes to go along with removal policy continued to build through the 1820s.

Next, a segment of the Creeks was induced to agree to removal in 1825. Called the Treaty of Indian Springs, this agreement was signed by Creek chief William McIntosh at his home at Coweta Town in Georgia. Primarily, McIntosh and his extended family desired removal; others of the tribe did not.

At this time, the Creeks were a loose confederation of many small tribes and clans with different towns, traditions and variations of the Muscogee language. These factions banded together for mutual protection and sent representatives to a periodic council meeting, but they did not have a single principal chief. Most of the Creeks believed McIntosh had no right to sign a treaty and condemned him to death for his action.

Because of this opposition, Congress voided the Indian Springs Treaty. The government called duly chosen Creek leaders to come to Washington to negotiate a new treaty, and the result was the Treaty of Washington, signed in 1827. The Creeks would exchange their lands in Alabama, Georgia and Florida for lands between the Canadian and Arkansas Rivers in the heart of the territory crossed by the Texas Road.

Ironically, this treaty had less favorable terms than the Indian Springs Treaty. The Creeks from Coweta and other towns began their removal to Indian Territory in 1828. William McIntosh's son, Chilly McIntosh, made several trips, bringing Creek migrants to their new land.

A good portion of these early Creek migrants settled on the Arkansas River in the Three Forks area, right along or near the Texas Road. When later migrations of Creeks occurred in the early 1830s, these individuals settled along the Texas Road near North Fork Town on the Canadian River.

TRAIL OF TEARS

In 1830, President Andrew Jackson pushed a bill through Congress titled the Indian Removal Act. With this instrument, his administration applied increased pressure on all the southeastern tribes to sign removal treaties. It took several years, with stiff resistance from some tribal members, to get

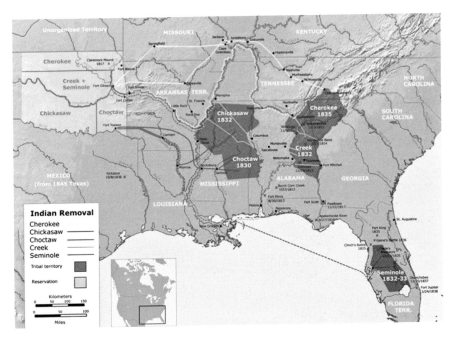

Many routes were taken by the five southeastern tribes, but each one proved difficult for the native people forced to seek a new home. *From the* Handbook of North American Indians.

treaties with the Chickasaws and Cherokees. By 1850, even the Seminoles of Florida were being moved west.

The relocation of over fifty thousand tribal members and their black slaves is remembered today as the Trail of Tears. Each of the five southeastern tribes divided their numbers into smaller groups and made the journeys between 1828 and 1854. The routes traveled from their homelands to Indian Territory took them over land, along rivers and across the Gulf of Mexico from Florida, Georgia, Tennessee, Alabama and Mississippi.

The one common denominator of all these journeys was the difficulty of the trek and the sorrow it brought. In many instances, the loss of life along the journey numbered up to several hundred in each migration. Travel was difficult and dangerous for anyone in those days. But the mass of people being forced to move—sometimes at gunpoint—exacerbated even the most common of difficulties.

Food for the people and their livestock was often scarce. Blankets were too few. Winter ice storms and record-breaking blizzards hampered travel. Spring floods brought cholera epidemics up and down the rivers. Wagons were too heavy for swampy roads, and boats were crowded to their maximum

capacities. Abject misery characterized the "trail where they cried," and the way was often marked with the graves of those who died.

In the removal treaties, the government had made grand promises to provide sustenance for the tribes along the journey and after they arrived in the Indian Territory. Individuals were to be supplied with foodstuffs and implements for hunting and farming. Sometimes these goods were delivered; at other times, they were not.

With some exceptions, most of the members of the Five Tribes had come from woodland areas—old-growth forests situated among rolling hills and ancient mountains. They were unused to the open prairie that characterized the western sections of the lands they had been ceded in Indian Territory.

For that reason, the Five Tribes settled primarily in the eastern half of what would become Oklahoma. This added to the significance of the Texas Road for the tribes, and the towns they created were often located along this main thoroughfare or along some of the feeder trails that connected to it.

Cherokee attorney Elias C. Boudinot created the town of Vinita, where the Jefferson Highway and Route 66 meet. The Ross and Rogers families of the Cherokee Nation settled near Chouteau's old post, La Saline, and developed the town of Salina. The McIntoshes of the Creek Nation chose lands near Three Forks, and the community of Creek Agency (later Muskogee) became one of the first along the road to receive a post office.

In the Choctaw Nation, Perryville, Atoka and Durant developed along the Texas Road. Chickasaw leader Benjamin Colbert operated a ferry across the Red River to Texas, and the nearby town of Colbert bears his name. The Seminoles settled west of the Texas Road but within easy access of both it and the California Road.

The Texas Road and today's Highway 69 traverse an eco-region known as the Cross Timbers. This broad swath of old-growth forest; hills and hollows; and low, rounded mountains may have helped ease the homesickness felt by the removed tribes. It bore some resemblance to the lands they had left behind.

Massive five-hundred-year-old post oaks can still be found in protected areas not cleared for farming. These often were landmark trees for the tribes—"council oaks" where important meetings were held or "whipping trees" where justice was meted out.

For the most part, the removed tribes settled east of the Cross Timbers, leaving the western sections of their nations open for hunting. Some of

the plains tribes also continued to use this region as their hunting grounds. Tensions between the plains people and the Five Tribes made additional forts necessary, and some were located along the major thoroughfare running through Indian Territory.

THE GOLDEN AGE

The members of the five southeastern tribes, and the slaves they brought with them, were forced to begin their new lives in Indian Territory with almost nothing. Yet it is a testament to their courage, faith, fortitude and determination that they soon thrived in their new lands. This was the birth of what today is known as "the Oklahoma Standard"—the ability to survive hardship with compassion, courage and cooperation.

In the two decades before the Civil War, they overcame the difficulties and depravations of the removals to begin new lives in the "Beautiful Indian Territory." This period of relative peace and growing prosperity is referred to as the "Golden Age."

These five tribes shared many things in common. Located geographically near one another for many years, the tribes had sometimes intermarried and

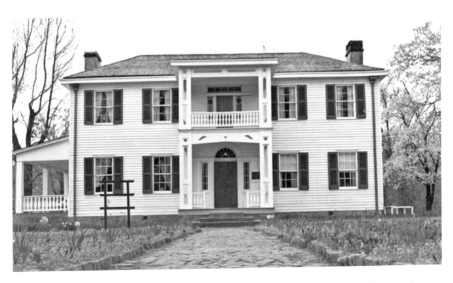

The George Murrell Home was typical of the southern plantation houses built after the removals and the only such grand home to survive today. *Oklahoma Historical Society.*

were generally on good terms with one another. Four of the tribes—all but the Cherokees—spoke the shared Muscogee language.

The Choctaws and Chickasaws were closely allied with each other, as were the Creeks and Seminoles. The Cherokees had long been neighbors with the Creeks and traded extensively with them. Yet each maintained their own sovereignty as "domestic dependent nations."

During the Golden Age, many churches and schools were built in the territory. Several missionaries had worked among the tribes in their lands in the Southeast. Some made the long journey with the Indians during the removals. Other missionaries and teachers arrived after the tribes had settled into their new homeland.

Already assimilated to many European and American customs of dress and lifestyle, the tribes built prosperous lives. The Choctaws were the first to adopt their own written constitution in their new land. They were successful farmers of cotton, corn and pecans and shipped their agricultural products back east.

The Chickasaws at first lived among their Choctaw cousins and shared their towns and schools. Later, they wrote their own constitution and established their sovereignty again. The Chickasaws had sold their eastern lands to the United States for approximately $500,000. With this money, they leased land from the Choctaws.

Part of the money was placed in a trust that yielded an annual income for the tribe of between $60,000 and $75,000. Their yearly annuity payments allowed them to thrive in a cash economy and made them less dependent on farming. The Creeks had been divided about ceding lands in the east and moving to Indian Territory. But the two factions chose to set aside their difference after reaching their new home. Schools were built, and the Creeks also adopted a constitution establishing a democratic form of government.

The Seminoles followed suit after they were settled and built their own schools and government. Cattle ranching was a large part of the Creek and Seminole economies, and peach orchards were abundant in Creek Nation, raised from seedlings carried with them from Georgia.

The Cherokees were the most bitterly divided over removal to Indian Territory. But in 1839, both factions of the Cherokees signed a new constitution and elected a chief. The Cherokees were strong believers in education and quickly created schools for their children. The Cherokees were considered one of the most literate and literary of the tribes, having developed a written language in the early 1820s.

It was all of these progressive efforts by the new settlers along the Texas Road that earned them the name "Five Civilized Tribes." By the 1850s, this

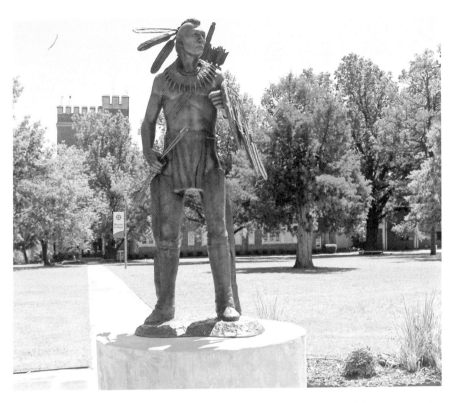

The *Chickasaw Warrior* statue stands at Bacone College (formerly Indian University), near the old Jefferson Highway in Muskogee. *Author's collection.*

term was frequently being used to describe the first tribes removed by the government to Oklahoma.

The Five Tribes had been ceded the entirety of Oklahoma, except for the panhandle. At the time, all the land between the Red River and the Platte River of Nebraska was considered Indian Territory. The government policy of Indian removal intended to move other eastern tribes to this northern swath of prairie. But Congress felt a need to keep a balance between slaveholding states and free states. The addition of Texas and the acquisition of New Mexico and Arizona Territories created a need for additional states north of the Missouri Compromise line. So Kansas and Nebraska Territories were created.

Following the Civil War, in which the Five Tribes were allied with the South, each of the tribes was forced to cede back some of its lands. To this area, more tribes would be removed in the following decades. Along the Texas Road in northeastern Oklahoma, additional tribes were settled

around the town of Miami, including the Eastern Shawnees, Miamis, Modocs, Ottawas, Peorias, Quapaws, Seneca-Cayugas and Wyandottes.

Oklahoma boasts of being "native America," and few other roads in America passes through as many different nations as does the Jefferson Highway. All along this route, the Native American culture is vibrant and visible for visitors to experience and enjoy.

5
TOURS, TRADE, TRAVEL

McCoy Tour

The removal treaties that the Five Tribes signed made provisions for an inspection of the lands they were being offered in western Arkansas Territory or, as it was soon called, "the Indian Territory." A Baptist minister named Isaac McCoy is credited with having coined the term Indian Territory.

McCoy had long been an advocate of the Indian removals from eastern lands to the vast American prairie. He believed that the Indians were too often taken advantage of by American settlers and that putting distance between the two cultures would protect the Indians. In time, he believed the native people would desire to form an Indian state and join the Union. McCoy did not hesitate to promote his point of view. He visited Washington on several occasions to put forth his proposal, hoping that he would be appointed an Indian commissioner. He was eager to help the Indians move westward and even volunteered to act as a guide for the tribal delegates who were sent to inspect their new lands.

In November 1828, McCoy met a group of Creeks, Choctaws and Chickasaws in St. Louis. With a military escort led by Captain G.H. Kennerly, an entourage of about forty-two people with some sixty horses made their way down the Texas Road. They traveled to the newly established Creek Agency at Three Forks. The first migration of Creeks had already been accomplished, and these individuals had settled around Three Forks along the banks of the Arkansas River.

The McCoy group proceeded to Fort Gibson, where they remained for a few days. Then they continued down the broad thoroughfare to the Canadian River. They camped here for a brief period and spent some time hunting buffalo. Being assured of the presence of buffalo in their new lands was important, especially to the Choctaws and Chickasaws. From the vicinity of North Fork Town, the Indian delegation traveled to Fort Smith along the new military road that followed the Arkansas River between Fort Smith and Fort Gibson. The Indian delegations then returned to their eastern homelands to prepare for their removal.

McCoy and the military escort returned to Fort Gibson and traveled back to St. Louis. McCoy would later work among the Creeks near Three Forks and help to establish Ebenezer Mission and Fountain Baptist Church.

McCoy's account of this western tour provides early documentation of the route of the Texas Road. Because he had worked as a surveyor and was traveling with a military topographer, McCoy's journal offers helpful insight into the terrain of the region through which the road passed. He noted the quality of the land, the types of natural resources available and distances between the few settlements that existed then.

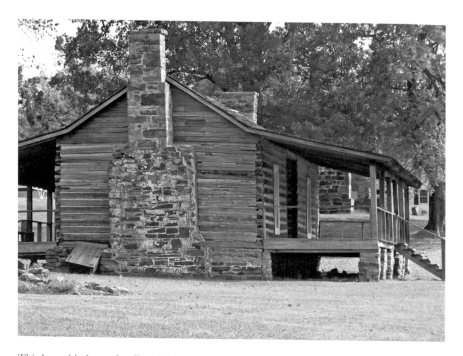

This log cabin located at Fort Gibson was typical of early homes among the Five Tribes. *Author's collection.*

Overall, Reverend McCoy presented a very favorable view of the Indian Territory, and his journal reflected his hope that the new lands would be suitable for the tribes who were soon to arrive. His vision of peaceful separation between the tribes and American settlement, however, never came to pass. The roads through the Indian Territory were already well traveled and would, over time, bring many others to tour the prairies.

Washington Irving Tour

In 1832, Congress created a commission to assist in the relocation and settlement of the Five Civilized Tribes in Indian Territory. This commission chose Fort Gibson as its headquarters, it being the westernmost U.S. outpost at that time and located in the heart of the lands being set aside for the Indians.

The commission was also given the task of making treaties with the plains tribes who roamed the western sections of the territory following the annual migration of buffalo. Until this time, many of these tribes had made no treaty with the United States and had had little contact with Americans.

Three men were appointed to the commission: Montfort Stokes, Reverend John Schermerhorn and Henry L. Ellsworth of Hartford, Connecticut. Congress put at their disposal the Mounted Ranger Company, under the command of Captain Jesse Bean, who would be stationed at Fort Gibson.

Captain Bean arrived at Fort Gibson in September 1832 and was shortly ordered to undertake an exploration of the western regions of the newly established Indian Territory. His mission was to try to make an initial contact with the plains tribes such as the Comanches and Pawnees.

In the meantime, Henry Ellsworth was traveling westward from Connecticut. On board a steamship on Lake Erie, Ellsworth met the famous author Washington Irving, who was interested in touring the West. Ellsworth invited Irving to come along with him to Fort Gibson, and Irving seized the opportunity. They continued by steamship down the Ohio River to the Mississippi River, then up to St. Louis, where they visited the Chouteaus and William Clark.

From St. Louis, they traveled to Independence and then started south along the Texas Road. A.P. Chouteau accompanied the party on this leg of their journey. They arrived at Chouteau's Verdigris Trading Post on October 8, 1832, and continued from there the four miles to Fort Gibson. It was necessary to cross the Grand River by ferry, which was operated by soldiers. Irving noted the whitewashed barracks of the fort in his journal.

At Fort Gibson, the Ellsworth party learned that Captain Bean's Rangers had left just three days earlier on his expedition into the plains. They wished to join the Rangers in this adventure, so Colonel Arbuckle, commander at the fort, dispatched two Creeks to find Bean with instructions to wait until Commissioner Ellsworth could join him.

Ellsworth's group spent the next two days getting outfitted for the trip. They limited their supplies to just what could be carried on their own mounts and a few packhorses. They followed the Arkansas River northwest, traveling through what would become Wagoner, but saw no towns back then—only the neat, well-stocked farms of Creeks on rich river bottom land.

They joined Bean's Rangers at the Cimarron River and proceeded across the prairie in a wide circle of what is now central Oklahoma. They arrived back at Fort Gibson on November 9, well satisfied with their journey. Washington Irving immortalized this adventure in his book *A Tour on the Prairies*.

Upon his return to Three Forks, Irving met the famous Sam Houston, who had built a home for himself on the branch of the Texas Road that led to Fort Gibson. Irving found Houston making plans to leave for Texas, and the night spent dining at his home probably revealed the growing political aspirations of the young protégé of President Andrew Jackson.

Called "The Raven" by his Cherokee friends, Houston had left a rising political career in Tennessee after resigning abruptly from the office of governor in 1829. He moved west to escape the scandal of a failed marriage and to live among the Cherokees he had grown up with back in Tennessee.

In Indian Territory, Houston married a Cherokee woman, Dianna Rogers, and established a trading post and home that he named Wigwam Neosho. The site of his trading post was near present-day Okay, and from his home he could watch the riverboat traffic on both the Verdigris and Grand Rivers

The Boling Place, near Okay on the old Texas Road, was believed to be the site of Sam Houston's Wigwam Neosho. *Author's collection.*

where they flow into the Arkansas. He surely also would have noticed the growing stream of settlers traveling southward along the Texas Road that forded the Arkansas River near his home.

On his arrival in Indian Territory, Houston almost immediately plunged into tribal affairs, often advising the commander at Fort Gibson on dealings with the Indians. His Cherokee friends asked him to travel with their second chief, Blackcoat, to Washington to address issues of Indian sovereignty.

After working with the Cherokees for three years, Houston left Indian Territory and Dianna for a new life in Texas. Taking the Texas Road south, he soon found himself in the center of the move for Texas independence, which he helped to secure. When the Republic of Texas was created in 1836, Houston became its first president and was eager to welcome migrating Cherokees and pioneering Americans coming south along the old trail that had long been an international road as well.

THE DRAGOON EXPEDITION

Shortly after Houston's departure, a new regimental unit called the First Dragoons arrived at its post at Fort Gibson, having taken the Texas Road south out of Missouri. This mounted unit had been established by Congress in 1833 to patrol Indian Territory and protect the important trade trails of the West.

Among the First Dragoons was a young lieutenant named Jefferson Davis, a West Point graduate from Mississippi. Davis, like most soldiers of his day, was expected to begin his military career on "hazardous duty" out on the frontier.

Early in the summer of 1834, a Texas man named Judge Martin left his home on the Red River and came into Indian Territory on a hunting expedition. He brought his sons and two slaves with him, and they made camp near the Washita River in the Choctaw lands. The camp was attacked by Comanches, and only one of Martin's sons survived. He was taken captive by the war party.

The Dragoons had not been at Fort Gibson long when word reached them that the young boy, Matthew Martin, was alive and being held by the Comanches. A military expedition was launched from the fort to rescue the boy. It would become known as the Dragoon Expedition and was the largest military undertaking in Indian Territory history.

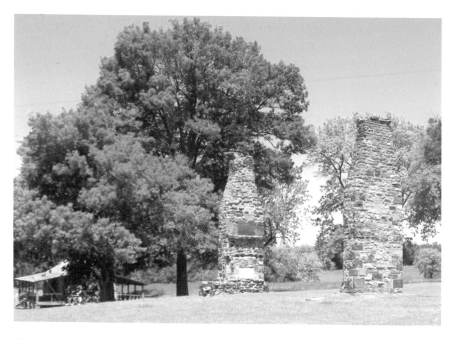

The stone chimneys are all that remain of the officers' quarters at Fort Gibson. It is often referred to as the Jefferson Davis House. *Author's collection.*

The Dragoons were a cavalry unit commanded by General Henry Leavenworth. They made an impressive picture as they rode out of Fort Gibson in June 1834. Hundreds of soldiers, both on foot and on horseback, made their way southwestward along the Texas Road with a long train of supply wagons and pack animals.

Just a few days earlier, flooding on the Arkansas River and much standing water had caused an outbreak of malaria—one of the worst the army had ever dealt with. The soldiers were in a poor state to head westward on an expedition to make contact with the Comanches and other western tribes.

Each company in the Dragoons had its own color of horse, specially matched. One company had all black horses, and the other five had bays, whites, sorrels, grays and cream-colored horses.

Many well-known military figures were a part of the expedition. In addition to Jefferson Davis and General Leavenworth, Henry Dodge, Stephen Kearny and Nathan Boone made up the ranks of the Dragoons. The famous western artist George Catlin also accompanied the cavalry and recorded the event in his paintings.

The Dragoons moved slowly across Indian Territory. The expedition proved difficult and costly in terms of the soldiers' lives. Because of the urgent pace in the oppressive July heat, poor drinking water and malarial fever, many sickened and died along the route, including General Leavenworth.

After leaving the well-marked Texas Road, the soldiers literally had to cut a new trail across unsettled wilderness as they made their way to the Washita River. The path they cut later was known as the Dragoon Trail and became a branch of the Texas Road.

After crossing the Washita, they moved westward toward the Wichita Mountains to arrive at a large Wichita village. Here, Colonel Dodge, who had assumed command after Leavenworth fell ill, met with Wichita, Kiowa and Comanche leaders.

An exchange of captives was made. The Dragoons had brought with them two Kiowa girls who had been taken captive by the Osages. The girls were exchanged for young Matthew Martin.

The Kiowas were greatly pleased with the return of the two girls, and the exchange created a sense of goodwill between the soldiers and the plains tribes. Matthew Martin accompanied the Dragoons back to Fort Gibson and then was returned to his grateful mother in Texas.

Davis continued at Fort Gibson until he resigned from the military in 1835 to marry Sallie Taylor, the daughter of General Zachary Taylor. He returned to his home in Mississippi and quickly moved into politics, eventually serving as president of the Confederacy. To this day, Fort Gibson and the Texas Road hold a close association with Jefferson Davis.

TRAVEL

At the time that the Dragoons were starting their expedition, a Creek citizen named James Edwards built a log trading post on the west bank of the Little River where it meets the Canadian. As a southern point of the Creek Nation, it served as an important trading location and a source of protection for both Creeks and Seminoles who were settling in Indian Territory.

Across the river and north by about a mile stood Fort Holmes, also built to provide protection for the new Indian settlers. These two companion structures were located on the Texas Road and saw a great deal of north–south traffic through the region.

This important road also connected Fort Holmes with Fort Gibson, from where most of its troops and supplies came. By the late 1840s, the California Road passed through the region as well, making Edwards' Trading Post one of the busiest trade establishments in the territory.

A small settlement of Creeks, Seminoles, Delawares, Shawnees and Quapaws grew around Edwards's store. At the log trading post itself was a cellar that was sometimes used as a jail until the outlaws could be transferred to Fort Gibson. It was through this area that the Dragoons made their expedition. Besides the rescue effort of the expedition, the Dragoons also hoped to make contact with many of the tribes in the region who, until this point, had made no treaties with the United States.

By the time the Dragoons arrived at Fort Holmes, many of the soldiers were so ill they could not continue; in total, about 150 died. Despite these losses, however, the Dragoons succeeded in convincing several plains tribes to send representatives up the Texas Road to Fort Gibson for treaty talks. In 1835, treaties were completed at both Fort Gibson and Fort Holmes with tribes such as the Comanches and Wichitas.

Making peace with the plains people was key to the government's goal of moving eastern tribes into the area. With treaties now in place, the developing Indian Territory became more than just a place to pass through. Trade and travel along the roads was safer, and posts soon developed near the forts and among the ever-growing numbers of Indians settling on the established trails.

A young Cherokee who worked at Edwards' Trading Post was named Jesse Chisholm. He married Edwards's daughter Eliza before moving on to establish his own trading post. Chisholm, a multi-lingual trader, was on good terms with all the tribes in the area, and it is for him that the famed cattle trail—the Chisholm Trail—is named. Cattle would soon use the trails once dominated by the buffalo.

Also increasing was commercial traffic along the Texas Road. Transit and stage companies competed for the traffic through Indian Territory to points farther south and west. The Overland Transit Company hauled freight from Texas to railroad terminals in Missouri.

The Butterfield Overland Mail had a government contract to haul the mail and military supplies to the forts on the western frontier. The El Paso Stage Line ran from Baxter Springs, Kansas, through the Three Forks and on to other points such as Fort Smith before crossing the Red River at Colbert's Ferry and continuing on to El Paso, Texas. The stage carried both passengers and freight.

Halted by the Civil War, service began again following the conflict. In the 1870s, the El Paso Stage was running a regular route from Fort Smith to the new railroad town of Muskogee along the military branch of the Texas Road.

In 1872, the stage line advertised in the Fort Smith newspaper that it would offer a fine four-horse stage leaving early each Monday, Wednesday and Friday and arriving at Muscogee Station by midnight. This nearly eighteen-hour journey, however, proved too strenuous for passengers, so the arrival time was pushed back to 11:00 a.m. the next day, with an overnight stay at one of the hostelries sprouting up along the way.

Passenger stages also traveled out of Fort Smith and Muskogee to the Indian towns of Tahlequah, Okmulgee, Wewoka, Atoka, Shawneetown and Kickapoo. Stage stops developed every ten miles or so, with notable locations such as Cabin Creek, Honey Springs and Boggy Depot.

Both the freighters and stage lines usually traveled with some type of armed guard to ensure the safety of the passengers and protect against thievery. Surprising amounts of fine furniture, dishes, linens and other niceties were brought to the homes of Indian Territory by freight haulers navigating the rutted roads that crossed the nations' land.

Though the wilderness images created by George Catlin, Washington Irving and other artists convinced easterners that the Indian Territory

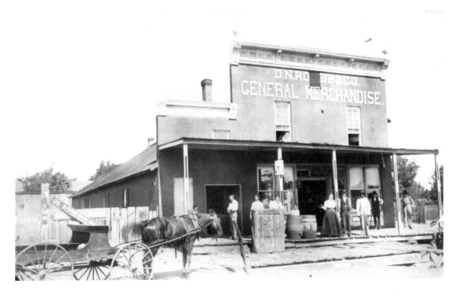

This early store in the Choctaw town of Atoka likely sat on the stage route through town. *Oklahoma Historical Society.*

was a primitive and dangerous place, the Texas Road and its many branches had a truly civilizing effect. A number of significant individuals in America's past traveled the road and recorded their own significance to our history.

6
A MILITARY ROAD

WESTERN MILITARY ROAD

With passage of the Indian Removal Act in 1830, the need for additional forts along the western frontier was soon realized. The lands that eastern tribes would be moved toward needed a military presence to provide protection and encourage peace among the various tribes.

Within a decade of the Removal Act, new forts sprang up west of Missouri and Arkansas. Many of them were in proximity of the Texas Road, and that fact soon gave the road a new name. It came to be called the military road. A few forts had already been built before Indian removals became official federal policy. Fort Smith was established in 1817, followed by Fort Gibson and Fort Towson in 1824. Fort Leavenworth, in what was then considered a part of "the Indian Territory," was established in 1827.

Congress authorized construction of a military road to link the western forts in 1836. It was to run from the upper Mississippi River to the Red River.

By this time, all of the Five Tribes had either begun or completed their migration to the Indian Territory. Other tribes were being settled in what are Kansas and Oklahoma today. The Osages, who had once dominated the Three Forks area, were moved to a reservation in Kansas.

Congress provided for the road to include Fort Leavenworth on the Missouri River in far northeast Kansas and Fort Gibson on the Arkansas River. The cost of the road was estimated at $35,000, a modest sum even back then. Most of the route was already improved as the Texas Road,

bringing down the cost of construction. Soldiers would provide most of the labor. Now the route was sometimes called the Leavenworth-Gibson Road.

Below Fort Gibson, the military road branched out to reach Fort Smith, Fort Towson and Fort Holmes. The section of road between Gibson and Fort Smith had been surveyed in 1825 and had been used by the Five Tribes on their journeys west.

Captain Benjamin Bonneville, assigned to Fort Gibson, had helped to survey the road to Fort Smith. A career military officer, Bonneville's life was made famous by another western treatise by Washington Irving. *The Adventures of Captain Bonneville* was published in 1837.

The Indian removals had brought an influx of over thirty thousand people to the reaches of the Texas Road. The military presence was stretched thin along this ribbon of highway, though Fort Gibson housed a large number of soldiers. Additional forts were deemed necessary.

In 1834, Fort Coffee, a small garrison guarding the Arkansas River, was established in the Choctaw Nation, not far from the Arkansas Territory line.

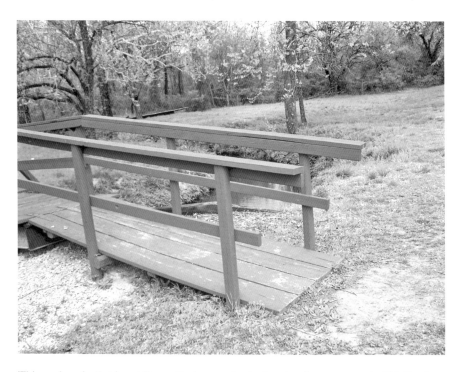

This modern footbridge at Honey Springs marks the location for a rest stop by Elk Creek. *Author's collection.*

Fort Scott was constructed in Kansas Territory in 1842. The military road was the primary factor in deciding its location.

Fort Wayne on the Illinois River in the Cherokee Nation and Fort Washita on the Washita River in the Chickasaw lands followed. Supply depots were established between the forts at convenient resting places already used by travelers and freighters.

A part of the plan for the beefed up military presence among the removed Indians was the relocation of Fort Gibson. Though it was a pivotal piece in the line of defense, it had proven to be a very unhealthy location. More soldiers died of disease than were ever threatened with violence at this outpost.

In addition, citizens of Arkansas wanted the post closer to them for protection and the economic benefit such an installation always provides. Fort Smith had been closed only a few years after Fort Gibson was established, though a town by that name survived. To the residents of Arkansas, Gibson was simply too far removed to offer any sense of security.

A commission was formed to choose a new site for Fort Gibson, sites for additional forts and the route that the military road would take to connect them. Colonel Zachary Taylor was on this commission at the start but was later replaced by two officers of the Dragoons: Captain Nathan Boone and Colonel Stephen Kearny. They, along with Major T.F. Smith, were organized at Fort Leavenworth in November 1836.

Boone, like his famous father, Daniel Boone, was a surveyor and, as a Dragoon, knew the Indian Territory well. The three commissioners traveled down the Arkansas state line in search of a more healthful location for Fort Gibson. They reported their conclusion in December that the site of Fort Coffee would be a likely choice for a larger military presence.

But the commission also stressed that it believed Fort Gibson should be retained. It was simply too important a facility and was located centrally among the Five Tribes. The commission's recommendation was that new quarters be built for the troops stationed at Gibson at a spot on higher ground above the Grand River. Arkansas' congressional delegation was not happy with this decision, however, and insisted a fort be located near the border with Indian Territory.

Progress on surveying the military road was slow, and little was completed in 1837. Colonel Kearny wanted to wait for topical engineers to provide expert direction on the completion of the road. While the commission had recommended a route that would run from Fort Leavenworth to Fort Coffee close to the Arkansas line, engineers would need to rule on its feasibility.

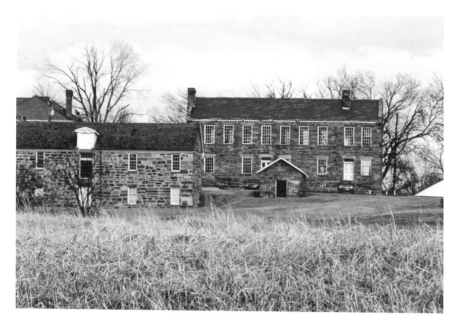

These stone buildings make up the "garrison on the hill" at Fort Gibson. *Author's collection.*

A topographical survey was completed by Kearny, Boone and engineer Charles Dimmock in October 1837. It was Dimmock's opinion that the Ozark and Boston Mountains would create difficulties for building the proposed road. He recommended the road be moved farther west.

This recommendation made the Fort Coffee location less desirable since it sat between the Ouachita and Ozark Ranges and would not be accessible except by the Arkansas River. By 1838, the government had decided to give the Arkansas congressional delegation what it wanted by rebuilding Fort Smith. An early military road still functioned between it and Fort Gibson. In the end, Fort Coffee became the site that was abandoned in favor of Fort Wayne, which sat on the road between Fort Gibson and Fort Smith. By 1842, Fort Wayne had been ordered abandoned in favor of Fort Scott.

Construction on the road between Fort Leavenworth and Fort Gibson finally began in 1838. Much of the route needed little work, as it had been used for many years already. By 1839, most of the road had been marked and improvements made where needed.

The value of the military road was the protection its line of forts offered to new settlers on the western frontier. Travel and trade had existed for many years before Congress authorized the military route, but they increased

A camp reenactment in the hills of eastern Oklahoma shows terrain that proved challenging for road building. *Author's collection.*

exponentially with the reassuring military presence. For several years after its completion, the military road provided the best route for travel between Iowa and Missouri to Arkansas, Indian Territory and Texas.

FORDS AND FERRIES

The increased military presence in the Indian Country drew new settlement and sparked new business enterprises. The military often operated ferries at the forts because most were located at a river. But at other locations, private ford and ferry operations also developed along the road, now regularly maintained by a government entity. Within a decade of the road's completion, private enterprise was maintaining additional fords or operating ferries along its route.

On the frontier, putting a bridge across a small creek or stream might be a matter of cutting a couple trees long enough to span the water and nailing spaced boards along their length. But bridges over the large rivers of the Indian Territory took more equipment, manpower and engineering than existed in the early days.

The only way to get across the rivers was to ford them—to wade into the water and hope to make it to the other side. Fording the rivers could be difficult—even dangerous—and was not for the faint of heart. If the river level was too high or the waters too swift, even the most intrepid traveler could not get across. When water levels were low, quicksand presented another challenge.

As more and more people began to travel along or settle near the military road, the need for accessible river crossings increased. And a few enterprising individuals saw a business opportunity in this need. At first, they managed the fords by keeping the banks clean and clear and sometimes offering canoe service to get across. In time, they started ferry operations along the rivers at these natural fording spots. As the removed tribes settled in the region, small communities would often develop around these locations, serving the needs of area residents and travelers who would come there to cross the river.

One of the earliest fords developed on the Arkansas was at Fort Smith. It was at this ford that Osage leader Mad Buffalo, son of Chief Claremont, gathered a group of several hundred warriors, intending to attack the fort. Major William Bradford hauled out his cannons and pointed them across the river at the Osage camp. The natives were convinced of the wisdom of not attacking and retreated back to their town on the Verdigris River. No shots were fired.

A ferry soon operated at this location, and traffic increased greatly as the California Road crossed out of Arkansas at this spot.

The road running from Fort Smith to Fort Gibson required a crossing of the Illinois River near the short-lived Fort Wayne. A Cherokee warrior named Tenkiller operated a ferry over the Illinois, and it is from him that today's Tenkiller Ferry Dam and Tenkiller Lake get their names.

Above the mouth of the Illinois is the waterfall on the Arkansas River that the French named *La Cascade*. It became known as Webbers Falls after Cherokee leader Walter Webber moved into the region and set up a trading post on the military road. Travel by river would halt at the falls when the river was low, so many travelers disembarked here and continued their journeys by wagon. It became a logical location for the Illinois Station ford.

At Webbers Falls, a ferry was begun by a Cherokee doctor named William Campbell. He operated two ferries: a steam ferry when the river level was high and a cable ferry when the water was low.

Campbell started his ferry out of necessity. His home was located at the river, and he would often have complete strangers stranded and camped in his yard or staying in his house because the river level was too high for them to ford. The falls, ford and ferry all contributed to the development of the towns of Webbers Falls on the west bank and Gore on the east bank.

Farther upriver on the Arkansas, the little Cherokee community of Frozen Rock and the plantation home of William Shorey Coodey had a ford and a ferry and even a landing for steamboats. The ford was called Rabbit Ford

after an elderly freed slave who had worked on the Coodey plantation. This ford would later be significant during the Civil War.

Fort Gibson operated a ferry on the Grand River just above its flow into the Arkansas. Some of the prominent travelers who utilized this ferry included Washington Irving, who had some very interesting adventures in fording streams while touring the prairie, and Sam Houston, who built his Wigwam Neosho just across the river from the fort.

In the Creek Nation, the Hitchita Ford on the Arkansas connected the Tullahassee Mission to Creek Agency on a branch of the Texas Road. Alice Robertson, Oklahoma's first congresswoman, wrote about traveling from the mission to Creek Agency for Thanksgiving one year. The Robertson family crossed the river at the Hitchita Ford in a wagon pulled by their faithful horse.

A well-known map of the Three Forks, known as the Meagher Map, shows a number of canoe crossings on the stretch of the Verdigris River from its mouth to its falls. Washington Irving also mentioned canoes being used to get travelers across the river. Likely this was a service for a fee before a ferry was put into use.

One of the better-known ferries on the Grand River near the military road was the Markham Ferry, which provided passage at Salina. It was also preceded by a ford and would have been used often by travelers along the Texas Road who paid a call at the home of A.P. Chouteau before proceeding on southward to his trading post at Three Forks. The Markham Ferry Dam created today's Lake Hudson.

Other notable fords on the military road are Rock Bluff on the Red River just above Colbert's Ferry and the North Fork ford near Eufaula, where the two branches of the Canadian River merge and which gave rise to North Fork Town. Also important was the Three Forks ford at French Point between the Verdigris River and Grand River. It became the Sutherland Ferry in later years.

Almost all the fords led to the development of ferries, then railroad bridges and, finally, highways and auto bridges. From these businesses grew other enterprises such as trading posts, liveries, taverns and hotels. Soon, a little community had grown around the crossing point.

Ferry operators charged a fee to carry individuals, their horses, oxen and wagons across the river. At busy crossings, a ferry operator could make a good living providing such transportation.

Some travelers grumbled about the fee, but most recognized that it was a service they needed, and it was better than risking their lives or possessions in turbulent water or hidden quicksand.

Ferries also allowed travelers to cross the river regardless of the water level. The only problem with the ferries was that when they were busy, people would have to line up at the crossing and wait their turns to get across.

Ferries continued in operation well after statehood in Oklahoma. By the 1920s, a push for paved roads finally had led to the building of bridges over the rivers for the development of the Jefferson Highway.

The security of the military road gave rise to many of the first businesses in the Indian Territory. The road had its vulnerabilities, however. The western line of forts had an average of only about four hundred men assigned to each of them at any given time. Between the forts, there were few true towns and only way stations to provide a place to camp and replenish water supplies.

The Indian County was occupied by the mostly peaceful Five Civilized Tribes and the more warlike plains tribes, which sometimes led to tensions among those occupants. The long distances between the forts and from the forts to eastern commercial centers also made them hard to keep supplied with both men and materiel.

As early as the 1840s, military leaders were expressing concern that these western forts would be hard to defend in a large-scale conflict. That would prove true when the devastating Civil War came to the area.

FOCUS OF THE CIVIL WAR

ALLIANCE TREATIES

In what would quickly prove to be a mistake, the government in Washington finally succeeded in closing Fort Gibson in 1857. Despite a move to higher ground, the post had continued to be an unhealthy location. The Five Civilized Tribes were settled and enjoying their golden age, and a "peace-keeping" force no longer seemed necessary among these tribes. Troops from Gibson were moved to posts farther west.

In the fall of 1860, the U.S. presidential campaign was being watched closely by the residents along the Texas Road in Indian Territory. The debate about slavery was of interest to the Five Tribes because some of their members held slaves. There was also talk in the campaign of changes being brought to Indian Territory, including the idea of individual land allotments. When Abraham Lincoln was elected and the Southern states began to secede from the Union, these events brought a great deal of concern to Indian Territory.

Both the Union and Confederacy recognized that Indian Territory would be important for troop movements in a war, but the South seemed more interested in this land lying below the Mason-Dixon line. Both sides recognized the need of support from the tribes of Indian Territory. But the actions each government took served to push those tribes toward the Confederacy.

With war looming on the horizon, the U.S. government pulled its troops from the forts in Indian Territory, leaving residents vulnerable to attacks

from western tribes and outlaw activity. Then, government officials delayed making an annuity payment to some of the tribes because they feared transporting so much money in a time of war. This left the tribes hurting financially at a time when crop production was poor. Both of these actions went against the terms of the removal treaties.

Conversely, the newly formed Confederate government made a concerted effort to woo Indian leaders to its side. The Confederate congress, meeting in Montgomery, Alabama, authorized an Arkansas lawyer named Albert Pike to negotiate alliance treaties with the tribes.

At first, many of the Native Americans were reluctant to engage themselves in "the white man's war" and tried to remain neutral. John Ross, a Cherokee chief, stated that the Cherokees and other tribes were bound by treaty with the United States, and as honorable men, they should abide by those treaties.

Ross hoped to maintain the fragile unity his tribe had found after years of conflict over removal. If he could urge his nation to remain neutral, perhaps they could avoid being pulled back into the factionalism that had plagued them for so long. Besides, the federal government held a large amount of money in trust for the Five Tribes. To sign a treaty with the Confederacy could mean a forfeiture of those funds.

With Confederate states on the east and south and only Kansas on the north siding with the Union, Indian Territory was caught in a vise. Aligning with the South seemed like the expedient thing to do. The Confederacy promised to make the annuity payment owed to the tribes if they would sign treaties with the South. Albert Pike traveled the road to meet with tribal leaders in a council near North Fork Town.

Creek leaders called for all tribal members to meet at North Fork Town to discuss their options. They met under a brush arbor near Baptizing Creek, not far from present-day Eufaula. Many speeches were made, and passions ran high.

Arguing that signing a treaty with the Confederacy would violate its treaty with the United States, Creek leader Opothle Yahola urged the tribe to retain a stance of neutrality. But he was unable to persuade the majority, who wished to form an alliance with the South, so Opothle Yahola led his followers to withdraw from the meeting. The remaining Creeks signed an alliance treaty with Pike while at North Fork Town. The Seminoles later signed their alliance treaty at Seminole Agency.

The Choctaws and Chickasaws were firmly in favor of a treaty with the Confederacy and quickly signed one with Albert Pike. Many individuals of these tribes owned large plantations and had benefited financially from the

labor of their slaves. Like their counterparts in the South, they did not wish to see slavery abolished. The Cherokees stood alone in trying to remain neutral, even though many among their ranks wanted to side with the South.

Pike traveled farther west in Indian Territory and secured treaties with the smaller tribes of the Wichitas, Comanches, Tonkawas, Shawnees and Delawares. These treaties were not for military support, however. They primarily were an agreement that these tribes would not conduct raids into Texas, as they often had done in the past. Pike suggested they conduct their raids into Kansas instead.

Eventually, after securing treaties with virtually every tribe in Indian Territory, Pike brought this to bear against Chief Ross. Many Cherokees, led by men such as Stand Waite, strongly sided with the Confederacy and began forming military regiments to involve themselves in the war.

Ross felt increasing pressure to sign an alliance treaty, and when the Union pulled all Federal troops out of Indian Territory to help with the war effort back east, Ross felt he had only one choice. Reluctantly, he signed the treaty of alliance, and Pike returned to Arkansas. Very quickly, as a reward for his service, Pike was made a brigadier general in the Confederate army. He was placed in command over the troops in Indian Territory.

Even with the treaties signed by their leaders, some individuals among the tribes wanted no part of the Confederacy or the war. A gathering of likeminded neutral Indians joined Opothle Yahola at his camp on the North

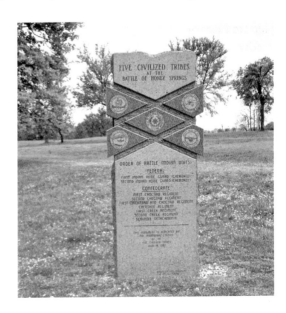

This monument at the Honey Springs Battlefield includes the seals of the Five Tribes, who all allied with the Confederacy. *Author's collection.*

Fork of the Canadian River. Within a short period of time, their number grew to about eight thousand.

This gathering worried Confederate leaders, who had been busily recruiting troops among the tribes in Indian Territory. As the neutral group began a journey toward Kansas, Albert Pike led an attack against these "loyal" Indians.

Three battles were fought before Yahola and his followers could reach the relative safety of Kansas. These skirmishes were the first military actions of the war in Indian Territory and some of the few that did not take place along the Texas Road. They served to alert leaders in the North that an army on the frontier would be necessary after all.

FIGHT FOR CONTROL

The flight of the loyal Indians proved as devastating to the Indians as the removals of years before. Yahola arrived at Fort Scott with only six thousand of his followers. By this time, the winter of 1861 was setting in, and these Indians were not dressed for the cold. The military at Fort Scott was charged with caring for the loyals but was hard pressed to get enough food, blankets, clothing and other supplies for them. The loyals would spend a miserable winter in Kansas.

But among Yahola's group were about 1,500 Creeks, 260 Seminoles and a collection of warriors from other tribes who were ready to fight and wished to enlist in the Army of the Frontier. The military was hastily forming new troops at Fort Leavenworth and Fort Scott.

At Leavenworth, a physician named James G. Blunt was among the first to volunteer. He had practiced medicine in Greeley, Kansas, for several years and was a staunch abolitionist. He joined the Third Kansas Regiment and was given the rank of lieutenant colonel.

This regiment was sent to Fort Scott to defend it against Confederate troops, under General Sterling Price, who was operating in the Springfield, Joplin and Carthage area of western Missouri, all on branches of the Texas Road.

After spending several months in 1861 in pursuit of Price throughout Kansas and Missouri, Blunt was made a brigadier general and placed in command of Fort Leavenworth. He was given the responsibility of organizing the loyal regiments of the Creek, Cherokee and Seminole refugees into a unit known as the Indian Brigade.

Among these warriors were free blacks and escaped slaves. With their enlistment in the First Indian Home Guard Regiment, they are believed to be the first black troops to serve in the U.S. military. A Second Home Guard regiment was organized in 1862, as more tribal members fled the Indian Territory.

Utilizing these troops, Blunt sent forces down the military road into the Cherokee Nation early in 1862. They reached the Cherokee capital of Tahlequah, but with most of the territory under Confederate control, they could not secure a base of operation there. So they returned to Fort Scott rather than remain in the territory. Returning with them was the Third Indian Home Guard, made up mostly of Cherokees who had left the Confederate Mounted Rifles under John Drew and Stand Waite.

Blunt then left Fort Leavenworth and personally assumed command of the Indian troops. He would later write of them that they remained on active duty until the end of the war and performed a great service for the Union cause. By 1863, Blunt had also added to his command one of the first volunteer African American regiments to fight in the Civil War: the First Kansas Colored Infantry.

Blunt would lead his troops to battles throughout Missouri and Kansas, as well as in the well-known clashes in northwest Arkansas at Pea Ridge and Prairie Grove. These battles were some of the first in which black troops took their places along the front lines.

With success in the Arkansas battles, Blunt was determined to secure Indian Territory for the Union. He ordered a subordinate, Colonel William Phillips, to occupy Fort Gibson.

The Confederates had briefly held Fort Gibson, but because it had been deserted for over four years, it was in a state of disrepair and vulnerable to attack. General Pike decided to build another fort nearby for the Indian troops under his command.

Pike located the fort right on the Texas Road, near an ancient Indian burial mound that had gained the name of the Big Mound. This mound sat at an advantageous location with a clear view of the road and of the Arkansas River. Even Fort Gibson, a few miles away across the Grand River, could be viewed through field glasses.

This Confederate post was named Fort Davis after Southern president Jefferson Davis. Besides Indian cavalry units, regiments from Texas and Arkansas were also garrisoned here. Though the post did not have a stockade, it was considered a secure location because of its commanding views. Cannons were stationed at Fort Davis facing Fort Gibson, the Texas Road and the Sutherland Ford.

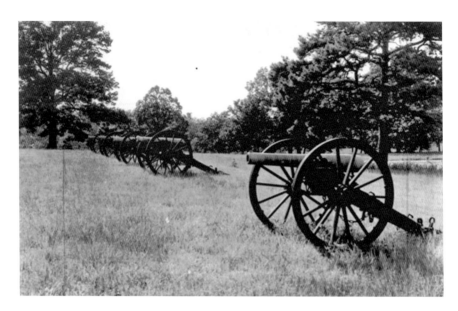

Cannons such as these often proved to be the most effective weapons in the battles along the Texas Road. *Oklahoma Historical Society.*

For a brief time, Pike used Fort Davis as his headquarters for Indian Territory, believing its central location on the Texas Road would enable him to keep the road under Confederate control and thus keep the territory under Southern jurisdiction. Within just a few months, however, after Confederate losses in Arkansas, Fort Davis was threatened by steady pressure from General Blunt's Indian Brigade.

With the First and Second Indian Home Guard regiments, Colonel Phillips reoccupied Fort Gibson in April 1862, shortly after the Union victory at Pea Ridge, Arkansas. With this success, the northern section of the military road between Fort Gibson and Fort Scott was under Union control. Pike was forced to withdraw most of his troops from Fort Davis. Under new command, the Confederates at Fort Davis tried to dislodge the Home Guard regiments, which were busily fortifying Gibson. Cannon fire roared back and forth across the river between the two forts but with little actual impact.

The countryside around the forts felt the repercussions for miles, bringing fear and uncertainty to the Creek and Cherokee Nations. Except for military movements, travel on the Texas Road ground to a halt after most families in the nations fled either to Texas or Kansas.

In December 1862, troops from Fort Gibson crossed the Arkansas River at Rabbit Ford, traveled up the military road and attacked and burned Fort

Davis. From that point on, the Cherokee Nation and much of the Creek Nation were considered Union territory.

But holding on to that territory depended on keeping the fort and the thousand soldiers garrisoned there supplied with food, fodder for horses, weapons and ammunition. Except for hay readily available from the surrounding prairie, all supplies had to be brought down the military road from Fort Scott.

Disrupting these supply lines became the focus of Confederate troops operating in Indian Territory. Though most Confederate forces had been driven south of Cherokee Nation when Fort Gibson was seized, the Confederates could still strike anywhere in the territory. Their goal in 1863 was to cripple Fort Gibson and retake it. One of the most effective ways to do this was to break the supply line.

On July 1, 1863, Colonel Stand Waite, head of the Confederate Cherokee Mounted Rifles, led an attack on a Union wagon train bringing supplies out of Kansas. This supply train included hundreds of wagons and was accompanied by regular infantry and cavalry units, as well as the volunteer units of the Third Indian Home Guard and the First Kansas Colored Infantry.

The wagon train was traveling down the old Texas Road. This broad trail crossed a stream called Cabin Creek near the present town of Big Cabin in Mayes County. Waite believed this crossing would provide the best opportunity for an attack. However, the commander of the Union forces, Colonel James Williams, learned of Waite's plans. He circled his wagons north of the creek and, on July 2, brought artillery into range and began a bombardment against Confederate troops dug into the brush on both sides of the rain-swollen creek.

A charge by the Union cavalry under cover fire by the First Kansas Colored Infantry eventually secured the far bank of the creek, allowing the infantry units to also cross. The Confederates were driven back but tried to regroup about a half mile south. They were again repulsed and scattered. Colonel Williams was able to get the supply train to Fort Gibson with an infusion of his additional troops and the much-needed supplies.

GETTYSBURG OF THE WEST

Ten days later, General Blunt joined Phillips at Fort Gibson with additional troops and more artillery. By this time, General Blunt's reputation as a bold

and disciplined fighter had been well established. Upon his arrival at Fort Gibson, the fort's name was changed to Fort Blunt, though it was referred to by this name only until the end of the war.

At this same time, Confederate troops were massing at the supply depot at Honey Springs, which sat on the Texas Road about twenty miles south of Fort Gibson. Honey Springs was known for having a good water supply and therefore had long made an excellent location for an overnight stop along the road.

Following the capture of Fort Davis, the Confederates set up a supply depot at Honey Springs in the Creek Nation. Warehouses were built to hold barrels of flour, sugar and sorghum, as well as bacon, clothing, camp equipment and gunpowder brought up from Mexico. There was also a hospital, powder magazine and officers' quarters located there.

With the intent of attacking Fort Gibson, about 5,700 Confederate Cherokee, Chickasaw and Choctaw troops under General Douglas H. Cooper were gathered at Honey Springs. A Texas cavalry unit was also a part of the troop buildup. While these troops awaited the arrival of 3,000 more from Arkansas, word reached the Union forces at Fort Gibson of the gathering.

As he had done on several other occasions, Blunt decided to strike first before the additional troops could arrive. Leaving Fort Gibson on July 16, troops from Fort Gibson forded the Arkansas River by flatboats and marched by night down the Texas Road.

The Battle of Honey Springs took place on July 17, 1863. It has been called the "Gettysburg of the West" because it was a turning point in the fight for control of Indian Territory. The battlefield straddles the Muskogee and McIntosh County line, through which the Jefferson Highway would later run.

Three thousand Federal troops under Blunt faced 5,700 Confederate forces under Cooper. The majority of the Confederate troops were Native Americans; General Blunt's forces were mostly Native Americans and African Americans. This was another significance of the Battle of Honey Springs. It was a truly American battle—a melting pot of races and cultures, including blacks, Indians, whites and some Hispanics serving in the Texas units there.

Blunt engaged the Confederate troops at a point where the Texas Road crossed Elk Creek. The First Kansas Colored Infantry played a key role in the Battle of Honey Springs. On that sweltering July day, the First Kansas held the center of the Union line and helped secure the victory against the larger Confederate force.

When the day of battle ended, the Confederate forces and many Southern sympathizers withdrew southward toward Fort Washita, Boggy Depot and the Red River. Before their retreat, Confederates burned everything at Honey Springs, including the supplies so they would not be useful to the Union forces.

Because of this Union victory, Fort Gibson—or Fort Blunt—was never again seriously threatened by Southern troops for the remainder of the Civil War. When Fort Smith in Arkansas was captured by Union forces later that year, both the Texas Road and the Arkansas River were securely in Northern control.

General Stand Waite and the Confederates continued to harass Union supply lines for the final years of the war. A second battle at Cabin Creek in 1864 resulted in the capture of nearly $1 million worth of supplies. Battles at Flat Rock Creek near the Texas Road north of Wagoner and against the steamboat *J.R. Williams* were also successful. But enough supplies made it through to Fort Gibson to keep it a Union stronghold for the remainder of the war.

MIDDLE BOGGY

Fort Gibson was the base of operation for most of the ongoing Union efforts to clear Confederate strongholds and give the Union firm control of the Indian Territory. Most Confederate regiments and sympathizing members of the Five Tribes had dug in at locations in the Choctaw and Chickasaw Nations around Atoka and Boggy Depot. They had decimated the Texas Road, destroying bridges, downing trees at fords and burning off pastureland in an effort to keep the Union forces from moving farther south.

Colonel Phillips set for himself and the Creek and Seminole troops he commanded the mission to push the Confederates into Texas. Leading 1,500 men, he left Fort Gibson on February 1, 1864, and headed south along the Dragoon Trail. This trail ran parallel to the Texas Road in a southwesterly direction. It took its named from the 1834 Dragoon Expedition that had included Lieutenant Jefferson Davis. Another Dragoon Expedition followed this same trail in 1855 and included then lieutenant colonel Robert E. Lee.

But on February 11, 1864, it was Union troops who camped beside the trail where these two Confederate leaders had once traveled. Phillips chose it because he expected to find better forage for the horses along this route.

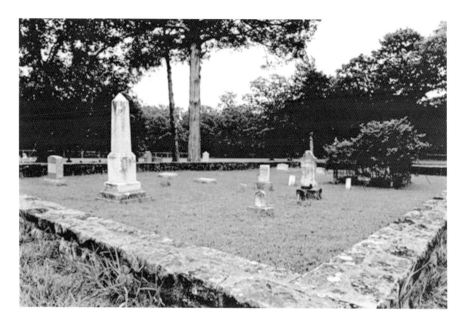

This Confederate cemetery is about all that remains of Boggy Depot, where Southern forces were headquartered at the end of the Civil War. *Oklahoma Historical Society.*

Phillips' troops paused near Edwards' Post, expecting to be joined by additional soldiers from Union-held Fort Smith, but they never arrived. His ranks consisted of the First Indian Home Guard, followed by an artillery unit with two howitzer cannons, three companies of Kansas cavalry and the Third Indian Home Guard in the rear.

On February 12, Phillips's troops continued southward to the Middle Boggy River. General Cooper had established a small Confederate encampment at the Middle Boggy. Early in the morning on February 13, Phillips engaged the Confederates at Boggy Depot, just southwest of Atoka.

After a brief but intense battle, the Confederates retreated, and another Union victory was sealed. The Battle of Middle Boggy was a minor skirmish in the war but clearly demonstrated that the Union was now fully in control of the Texas Road and Indian Territory.

The Civil War had a devastating impact on Indian Territory. The successes achieved by the Five Tribes in their golden age were destroyed, and few buildings were untouched by the intense guerrilla warfare.

For the final months of the war, supply raids and guerrilla attacks by gangs such as Quantrill's Band terrorized what was left of the civilian population. Confederate general Stand Waite stubbornly persisted in the fight, but most everyone else recognized that the end was near.

Waite's raids secured much-needed supplies, which were shared among the troops and their impoverished families. These small victories fed the Southern sympathizers, but Waite had no success in driving out the Federal troops.

Stand Waite holds two distinctions in the Civil War. First, he was the only Native American to attain the rank of general. Second, he was the last Confederate general to surrender at the war's end. While Robert E. Lee had surrendered to General Grant in April 1865, news of the surrender did not reach Indian Territory until June of that year. General Waite officially surrendered to Union officers on June 23, 1865, at Doaksville, Choctaw Nation.

Slowly, members of the Five Tribes returned to what was left of their homes. The rebuilding process began that summer of 1865, but in many ways, the fate of the tribes was forever changed by the "white man's war."

8
THE CATTLE TRAIL

THE SHAWNEE TRAIL

The decade following the Civil War is often thought of as the era of the cowboy. It is one of the most romanticized aspects of the American West story. And it all began along that old trail used by the buffalo for eons before the road was torn by war.

To move cattle to market meant getting Texas longhorns to the railheads in Missouri. Driving those cattle northward were young men, many of whom were still in their teens. Thus, they were called "cow-boys."

While millions of head of Texas longhorn cattle were driven north to railheads and meat-processing plants after the war, cattle drives actually began much earlier. As the Five Tribes were settling in their new homelands in the 1830s, cattle were being driven into and through the nations, seeking markets in the expanding Midwest.

At first, the fledgling cattle trail was simply called "the trail," but because it followed the Texas Road, it was also referred to as the Texas cattle trail. Traffic steadily increased in the two decades before the Civil War.

Citizens of the Five Nations generally welcomed the herds driven through their lands because they had not yet developed herds of their own. Many enterprising Indians charged a toll for a trailing herd to pass through their property, so the cattle provided much-needed income for the removed tribes. Others offered "grazing rights" to the Texas ranchers and charged a fee for cattle to pause in Indian Territory to fatten up before arriving at the railheads.

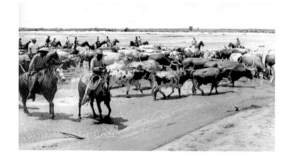

One million head of Texas longhorn cattle crossed Indian Territory, much of them along the Shawnee Trail. *Oklahoma Historical Society.*

The cattle were herded from Texas towns as far away as Brownsville, then they converged at San Antonio and traveled northward through Waco, Dallas or Fort Worth. The primary ford of the Red River into Indian Territory was located at Rock Bluff, just west of Colbert's Ferry. The cattle trail then followed the Texas Road to Boggy Depot and on to Fort Gibson.

From these two locations, the trail would split, and some cattle were herded into northwest Arkansas. Most continued along the old Osage Trace route into Missouri toward St. Louis with its railroad connections to Chicago and Cincinnati, two meatpacking centers.

At some point, the trail came to be called the Shawnee Trail. The exact reason for this name is unclear, and there have been several suggestions for the designation. It passed near a Shawnee village on the Texas side of the Red River and moved through an area known as the Shawnee Hills in the Choctaw Nation, near the Canadian River. These locations may have given the trail its name.

One major terminus of the trail became Sedalia, Missouri, where the Shawnees had traditionally lived. This fact may have given rise to the name. The cattle route was also called the Sedalia Trail at times. The Union Pacific Southern Branch had reached Sedalia in 1861, making it an important destination for the cowboys and their herds.

Early maps show that the Shawnee Trail followed the route of the Texas Road through the eastern section of Indian Territory. Like the Texas Road, it had its branches dependent on conditions of the road and the many streams it crossed. North of Fort Gibson, the trail might follow the early Osage branch to Maysville, Arkansas; move into Missouri to Sedalia; or continue north along the Spring River toward Baxter Springs, Kansas.

By the 1850s, thousands of head of cattle were being driven over the Shawnee Trail. But the cowboys encountered resistance from farmers who were settling in the Missouri and Neosho River Valleys. The Texas longhorns often carried a tick that transmitted a disease called Texas fever to other

cattle. The longhorns had long developed a resistance to the disease, but other breeds were vulnerable.

The issue came to a head in 1853, when some three thousand longhorns were trailed up the road to Missouri. The drovers met armed men determined to deny them entrance into their towns. The cowboys and their herds were turned back and forced to follow the trail back to Texas.

Subsequent trail drives found ways to skirt the towns where resistance was greatest, and the herds continued to get to the railheads of Missouri. But this made the antagonism between the farmer and the cowboy even greater. By 1855, vigilante committees were working to keep the longhorn out of Missouri.

Soon, the Shawnee Trail had developed a branch that stayed in Kansas following the Neosho River and ended in towns like Fort Scott and, later, the more western town of Abilene. This branch became known as the West Shawnee Trail, while the original route gained the name East Shawnee Trail. Both trails were being utilized up to the outbreak of the Civil War.

Demand for Beef

Commercial cattle drives halted during the war, but cattle, horses and mules were driven between forts by the military for the duration of the conflict. Following the cessation of hostilities, the dust completely settled on the trail for about a year before the cattle drives roared back to life in 1866.

Conditions following the Civil War were perfect for the cattle drives. During the war, the longhorns had proliferated in Texas. A glut of beef in Texas drove the price of a head of cattle down to three to five dollars.

Texas had only a few railroads, and much of the track had been poorly maintained while the war raged. What track existed served mostly Texas cities and a few southern destinations in Arkansas and Louisiana. But there was little money in the South for purchasing beef.

Meanwhile, in northern cities, there was a great demand for beef. During the war years, meat supplies had been available mostly for the military. With those constraints lifted, beef prices soared, and a head of cattle could bring forty to fifty dollars. A Texas rancher could make a small fortune if he could just get his cattle to the northern markets.

Estimates say that about 250,000 head of longhorns were driven north in the first year after the war. Despite the continued resistance from Missouri

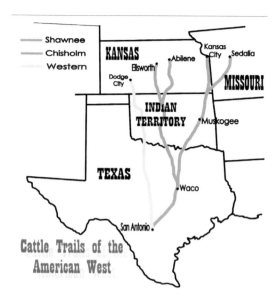

Connecting Texas cattle ranches to Missouri and Kansas railheads created the colorful cowboy era of the American West. *Author's collection.*

farmers, ranchers and their drovers found the promise of high-dollar payouts too lucrative to allow threats to stop them.

Violence against the drovers continued, and the experience of one young cowboy named James Daugherty was typical of what many experienced. The sixteen-year-old was working with a small crew to trail about 500 longhorns into southeast Kansas. A group of "Jayhawks" waylaid the herd and stampeded it. One drover was killed, and according to Daugherty, he was tied to a tree and whipped. After his release, he buried his fellow cowboy, rounded up about 350 of the scattered longhorns and made it safely to Fort Scott.

Eventually, the Missouri legislature passed laws banning Texas cattle from entering the state. At the same time, railroads were being extended west, and Kansas towns were springing up along these new lines. Enterprising businessmen like livestock dealer Joseph McCoy built stockyards at the new terminus of Abilene on the Kansas Pacific Railroad. The West Shawnee Trail quickly outpaced the eastern branch, as Abilene became the destination point for most of the Texas herds.

With more settlement in southeast Kansas bringing farmers and fences, more western trails were developed that skirted the new population centers. The result was that the Shawnee Trail saw the herds dwindle, and by the 1880s, few longhorns were driven along its length from Texas to Missouri. The cattle drive era as a whole didn't last much longer.

THE COWBOY WAY

Despite the brevity of its existence, the cattle drive era had a tremendous influence on the American West, on Indian Territory and on the road itself. After the horrors of a war that had torn the country apart and left it in tatters, the cattle drives offered something beyond beef. They were a symbol of resurgence, of enterprise, of western expansion and of the vitality of youth.

Soldiers hardened by the war, boys with few other job prospects, adventurers and entrepreneurs who invested everything they had became cowboys. The work was hard but satisfying. They endured difficult terrain, treacherous streams, cantankerous cattle, cold and heat, rainstorms and hailstorms and dust, dust, dust for a paycheck that might not last until they got back to Texas.

It was no wonder they were the romanticized heroes of dime novels in their day and continue to be the symbol of the American West to most of the world. The trails became a part of the American lexicon, and their names are still known today: Shawnee Trail, Chisholm Trail and the Great Western Trail. Every one of these hard-packed roads became the routes of later railroads and highways. They changed the landscape.

Cowboys were the hardworking, hard-driven men who would later become some of the wealthiest leading citizens of towns stretching from Texas to Montana. But they were not the hard-fisted stereotype created by Hollywood in the golden age of the western movie or television series. These cowboys were Indians, former slaves, Hispanics and other immigrants. They were mostly young and often illiterate, but they were also honest, polite, respectful and courageous.

The cattle drives left an indelible mark on Indian Territory. While most tribal members raised a milk cow or two, along with a few chickens and lots of hogs, cattle ranching was not a common pursuit until the massive herds invaded the nations.

Tribal members learned that raising cattle could be more profitable than any other form of agriculture. This was due in part to the peculiarities of landownership under the Five Tribes. Members of the tribes could claim and use large tracts of land or could rent them out to stock raisers.

The prairie grasslands lying west of the road were well suited to fattening the cattle brought up from Texas. Except for the rich river bottomlands, much of the prairie had a layer of sandstone beneath the topsoil. This made the region better suited for grazing cattle than for cultivating crops.

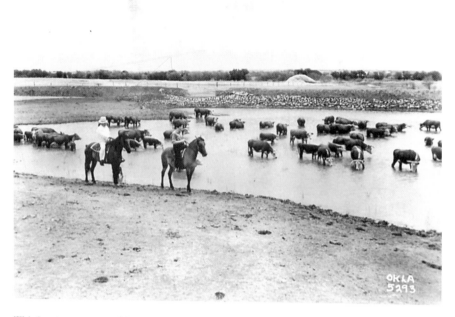

This herd was a part of Warner-Borum-Warner Ranch west of Muskogee. *Oklahoma Historical Society.*

Cowboys would drive the Texas longhorn northward, usually in the spring. Towns along the trail were a sight to be seen when the herds would arrive after weeks on the long, dusty trail. It was said that the dust billowing from the road could be seen for a good distance, warning laundresses to get their wash off the line.

These cattle were often fattened on Indian land for a few weeks and then continued their march to northern markets. They arrived in Indian Territory thin and weak and were herded out fat and strong after grazing on the rich prairie grasses.

Some stockmen from Texas moved into Indian Territory and married native women. This gave them access to tribal land. Several large ranches developed along the Texas Road and stretched for miles beyond it, with boundaries marked only with stones at the corners of their spreads. It was not unusual for these men to claims thousands of acres of land and run tens of thousands of cattle on it.

Each of these ranches provided employment for around twenty ranch hands throughout the year. The fall and spring round-ups of these huge herds would swell the payroll to double or even triple that number, as

white, Indian, black and Hispanic cowboys found work in bulldogging and branding. The yearly round-up must have been a colorful sight in every sense of the word. These ranches poured thousands of dollars each year into the local economy.

By the 1870s, communities along the Texas Road were becoming railheads and cattle towns themselves. Some had stockyards and, eventually, meatpacking facilities. Many a merchant became a cattle rancher simply because the Indians traded with livestock instead of cash.

The cattle drives were replaced with local ranches in Indian Territory supplying beef to northern markets. Ranching is still a vital industry along the road, which is now a highway for moving many other kinds of goods.

9

THE KATY RAILROAD

THE RAILROAD RACE

Because the Five Tribes had signed alliance treaties with the Confederacy, they had to sign new treaties with the United States after the Civil War. Called the Reconstruction Treaties of 1866, these new agreements demanded many concessions from the tribes.

They were required to cede back to the government several million acres of land in the western sections of Indian Territory. The Five Tribes had never occupied these lands, and the region was still hunted by the plains Indians. The government planned to move these tribes to Indian Territory permanently.

The 1866 treaties also required the Five Tribes to free their slaves and offer them citizenship in their nations. The result was that many of the old plantations along the Texas Road were soon occupied by former slaves who, as citizens, had the same rights to land as all other members of the tribes.

The Cherokees, Creeks, Seminoles, Chickasaws and Choctaws all had to agree to form a territorial government, write a constitution for their territory and begin the process of becoming a state. The Choctaw treaty even suggested a name for this Indian state. It was to be called Oklahoma, from two Choctaw words meaning "red people."

Finally, the Five Tribes were required to allow railroads to cross their nations. Before this time, the Indians had steadfastly refused railroad rights of way. This was a large part of the reason the cattle drives through Indian Territory had been necessary. With the 1866 treaties, the tribes agreed to allow one east–west railroad and one north–south railroad to enter the territory.

In a series of Railroad Acts beginning in 1862, the government had sought to incentivize railroad construction across the continent. Few lines existed west of the Missouri River, and the war had brought all new construction to a halt. By 1866, the government was eager to press for new rail lines to be laid across the West.

The Railroad Acts sought to aid the railroads in building across the heartland of America. Before then, railroads were short lines between two population centers where there was a ready market for shipping goods and passenger service. Out west, there were few towns and far less business for the railroads.

To encourage the railroads to venture west, the Railroad Acts gave the railroad companies large sections of land where they would be free to create towns by parceling out these sections and selling the lots at a profit. Many of the cities and towns between the Mississippi River and the Rocky Mountains were "railroad babies"—towns given birth by the rail line. A transcontinental railroad had been a dream of eastern investors and politicians since the gold rush days of 1849. Like so many other issues, however, the route the transcontinental line should take was a matter of contention between the North and the South. A stalemate kept anything from being developed, and no incentives could be agreed on.

During the war, with Southern politicians absent from Congress, the first railroad incentives were offered. Huge grants of land and large cash subsidies made crossing the sparsely populated continent financially feasible. Soon, eastern investors such as J.P. Morgan, Jay Gould and John Rockefeller were organizing railroad companies and incorporating them in Missouri, Iowa and Kansas.

Once the 1866 treaties were signed by the Five Tribes, the government announced that Indian Territory was open for railroad development. The Union Pacific Railway Company, Southern Branch, was chartered by the State of Kansas to build from Fort Riley, Kansas, to the state's southern boundary. Soon, other newly incorporated companies were building across Kansas, each with an eye on the lucrative Texas cattle market.

The tribes of Indian Territory were aware of this fever of railroad construction. They reminded the secretary of the interior that they had all agreed that only one north–south railroad would be allowed to cross their nations. They requested that this treaty obligation be honored by the federal government.

As a result, the secretary announced that only one line would be allowed to cross the territory toward Texas. The government would offer an additional land grant for the first railroad to lay tracks to Indian Territory. Again, the Indians protested. No such land grant had been agreed to by them. So cash incentives were all the government could offer.

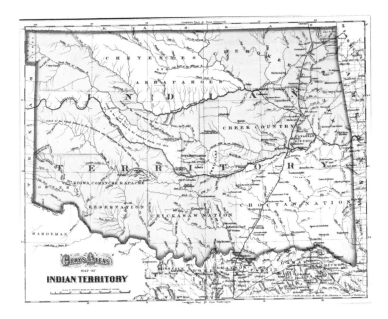

This *Gray's Atlas* map of Indian Territory shows the only existing rail line for many years.

In January 1870, the Leavenworth, Lawrence and Fort Gibson Railroad was ninety miles from the Indian Territory border. The Kansas and Neosho Valley Railroad, known as the Border Tier Road, was sixty miles from the border, and the Union Pacific Southern Branch was one hundred miles away. Determined to cross Indian Territory, the Union Pacific changed the name of the railroad to the Missouri, Kansas & Texas or, as it was soon called, "the Katy."

When the managers of these three railroads learned that the Department of the Interior intended to honor the treaties and allow only one southbound railroad to cross the territory, a railroad race was on.

Since one man, James F. Joy, owned both the Leavenworth line and the Border Tier Road, he concentrated on building the Border Tier because it was closest to reaching the Kansas state line. Heading south out of Fort Scott, Joy's tracklayers raced to reach Baxter Springs.

It was known that Baxter Springs sat near the state line, and once it was reached, the race would surely be won. Meanwhile, the Katy, owned by Levi Parsons, was struggling to cross rain-swollen creeks between Emporia and Chetopa, which sat near the state line in the Neosho River Valley.

In May 1870, it appeared that the Border Tier Road had won the race. On May 4, the Border Tier tracks reached Baxter Springs on the east branch of the Shawnee Trail. The Kansas line lay just a few miles beyond this city.

On May 12, Baxter Springs citizens held a big celebration to welcome the railroad to their town. After a high time on the town, the drunken Border Tier tracklayers scattered to the four winds. Cherokee attorney Elias Boudinot had participated in the celebration, lending credence to the supposition that the Border Tier had reached the Cherokee Nation.

But this wasn't true. Boudinot had cast his lot with the Missouri, Kansas & Texas. He was part of a plan to deceive the Border Tier officials into thinking they had won the race to Indian Territory and relax their building pace.

In fact, Baxter Springs sat on the boundary between Kansas and the Quapaw Nation, not the Cherokee Nation. The Quapaws had never signed a treaty allowing a railroad to pass through their land. The Border Tier Road would have to lay track another seventeen miles west to Chetopa before it could enter Indian Territory.

The Katy was still thirty miles from Chetopa at this time. Determined to win, the Katy workers were laying more than a mile of track a day. Joy's workers had to be rounded up again, and the Katy general manager used this opportunity to hire many of them away from the Border Tier.

By the end of May, the Katy had closed the gap and was gaining on its rival railroad. On June 6, 1870, the Katy had laid rail past Chetopa and across the Indian Territory line.

Chetopa citizens also held a huge celebration, for the coming of the railroad was a great economic boon to any town. Again, Elias Boudinot was a part of the ceremony. He, along with his uncle General Stand Waite and many Kansas dignitaries, rode in a passenger car behind a wood-fueled Grant 4-4-0 steam engine across the state line and back—a twenty-two-minute trip.

The Katy had won the race to Indian Territory. Its win was certified by the governor of Kansas, and President Ulysses S. Grant authorized the Missouri, Kansas & Texas Railroad to cross Indian Territory. In August of that year, the Texas legislature gave the Katy rights to cross its state from the Red River to the Rio Grande.

CROSSING INDIAN TERRITORY

When the Missouri, Kansas & Texas Railroad won the right to cross Indian Territory, its managers believed they could cross quickly through Indian lands to reach Texas. But that proved not to be true.

One of the first obstacles was in dealing with the Atlantic & Pacific Railroad (A&P), which had won the east–west right of way through Indian Territory.

Actually, the A&P had faced little competition since the Ozarks of Missouri, Arkansas and the Cherokee Nation would make railroad construction costly.

When A&P officials learned that there would be no land grants in Indian Territory, this also lessened the appeal of building through the territory. The A&P built westward to the Katy line and simply stopped there.

This juncture of the two lines was the location of a new town built by Katy insider Elias Boudinot. As a Cherokee, with full rights to all the land he cared to claim, he fenced nearly two square miles of property and developed the town site of Vinita, named for famed sculptress Vinnie Ream. The two railroads would cross through his town. For a time, the Katy and the A&P wrangled over right of way in a sometimes contentious manner, but with Boudinot's backing, the Katy ruled the day.

The railroad workers were also hampered by early spring rains that turned the prairie to mud. Then, mosquitoes nearly drove them crazy as they worked through the swampy bottomlands, following the Grand River southward.

By June 1871, they had just reached Pryor Creek, fifty miles from the Kansas border and another fifty miles away from Fort Gibson. Overland freight haulers were soon bringing up loads of cotton to Pryor Creek on the Gibson Road, as it was now being called.

Fort Gibson was the planned location for the Katy's primary depot in Indian Territory at roughly the halfway point between Kansas City and Dallas. The road to Fort Gibson at Three Forks was the oldest in the territory and well known beyond its borders. Katy managers believed it would be relatively easy to get to Fort Gibson.

The tracklayers and surveyors were aided by the existence of the broad, well-worn road. The tramp of longhorn hooves in recent years meant the roadbed was smoother than when it was used mostly by metal-rimmed wagons. The fords and stream crossings were well marked. The work should have gone smoothly as they pressed southward, but frustration was their lot.

They faced the open hostility that many Cherokees felt toward the railroad. Individual Indians fenced off the best timberlands, forcing the railroad to negotiate with dozens of Cherokees for railroad ties instead of buying them through the Cherokee national council.

So frustrating was the lack of cooperation by the Cherokees that the Katy managers decided to change the course of the railroad. Instead of following the military road into Fort Gibson, the rail line would veer to the west on the main Texas Road so it would enter the Creek Nation as soon as possible.

By the end of July, the line had advanced only ten miles to Chouteau's Creek, and it was late August before it passed Flat Rock Creek to arrive

at the Verdigris River. Here, a depot was established that gained the name Gibson Station at the point where the military road had veered east to Fort Gibson. Passenger service from Gibson Station began in September 1871. A survey of the Three Forks region revealed there were seventy-five thousand head of cattle in the vicinity. A depot here could be profitable.

When the rail line reached the Three Forks area, two river bridges had to be built—first over the Verdigris and then three and a half miles farther south over the Arkansas. The railroad supervisor expected to have the bridge over the Verdigris completed by September 15 and over the Arkansas by October 1. Again, these deadlines proved unreachable.

Because the ironwork had to be shipped in from the American Bridge Company in Chicago, the three spans of the Verdigris Bridge were not in place until October 1. On that fateful day, the center span collapsed, killing several workers and injuring many more. A new span would have to be shipped in. But on October 8, the Great Chicago Fire broke out, and the American Bridge Company had to delay all its shipments.

Work resumed after this delay, and the Verdigris Bridge was completed by the end of October. The tracklayers, who normally could lay a mile of track a day, took eleven days to cross the three and a half miles to the Arkansas, delayed this time by heavy rains. The road became a slick bog. Then, on November 17, the Arkansas flooded and washed out the framework for its bridge. The workers had to start over once again.

By December 7, the bridge was completed and ready for track to be laid across it to the site of old Fort Davis. This was the original site chosen for a large depot in the Creek Nation, but the terrain proved too uneven for the many side lines needed for switching engines. So the tracklayers slogged through more rain and mud to a site three miles farther south.

In a ceremony to celebrate finally reaching this milestone, the first steam engine crossed the Katy's Arkansas River Bridge on Christmas Day 1871. The General Grant made the trial run across the bridge, which must have been a great satisfaction to the weary workers who had toiled long and hard for so many months to finally reach the heart of Indian Territory.

At a point three miles from the Arkansas, the railroad surveyor planted stakes marking the location of the depot, sidings and wagon yard. It would quickly gain the name Muscogee Station because it was the primary stop within the Muscogee (Creek) Nation.

By New Year's Day, the railroad workers had laid track those three miles south to the Muscogee Station site. The General Grant steam engine arrived, and it was on that first day in 1872 that the town of Muskogee was born. A tent city

sprang up almost overnight. This depot was the end of the northern division, about 113 miles south of Parsons, Kansas (named for Katy owner Levi Parsons).

Through a cold and snowy January, the rail workers pressed southward, past a landmark known as Chimney Mountain to a point twenty miles south of Muskogee. Here, the town of Oktaha sprang up. As the Katy moved through the Creek Nation, the names chosen for the towns created all were given Creek names. Oktaha was named for Creek leader Oktarharsars Sands.

Thirteen miles south, they reached the Honey Springs battlefield site, and by mid-February, they were ten miles farther south at a site that became the town of Checotah, named for Creek chief Samuel Checote. Ahead of the tracklayers, the bridge builders were already working on crossing the Canadian River near North Fork Town. This town picked up and moved to the iron head, a supply dump established at the river. The town became Eufaula, named for a Creek town in their eastern homelands.

The Canadian River marked the boundary to the Choctaw Nation. Trouble with bridge spans here caused another delay for the Katy, giving the railroad workers a pause at Eufaula in April 1872. A wild tent city developed, and every manner of illicit activity was pursued. The Creeks were happy to see the railroad and its hard-drinking workers move on to Choctaw Nation.

The line continued ever southward, following the old cattle trail and stage route. It crossed Rock Creek and Roasted Terrapin Creek before reaching a coal-rich area known as the Cross Roads. This was the location where the California Road crossed the Texas Road. It was a natural trading point, and the little towns of Bucklucksy and Perryville had existed here since the Choctaws arrived. A trader named J.J. McAlester had operated a store near the Cross Roads since 1869.

When the Katy surveyors established another depot near McAlester's store, the nearby towns moved to this location. The depot was named McAlester, and Perryville and Bucklucksy soon ceased to exist.

Continuing southward, new "tank towns" were created every ten to fifteen miles where the steam engines would need to stop to take on water and fuel.

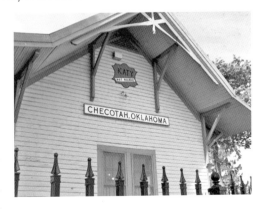

The Katy's route through the Creek Nation created many "tank towns" such as Checotah. This Katy depot now serves as Checotah's history museum. *Author's collection.*

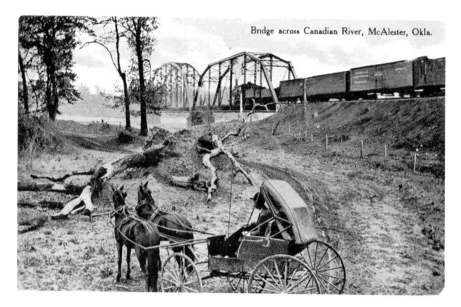

The buggy driver in this postcard may be waiting for the train to pass before crossing the Canadian River via the bridge. *Author's collection.*

Savannah, Kiowa and Stringtown developed between McAlester and the old Choctaw town of Atoka. Named for a Choctaw leader, Atoka was near the battlefield site of Boggy Depot.

Crossing Island Bayou, the boundary line between Choctaw and Chickasaw lands, at Fisher Station, the railroad was nearing the Red River in the fall of 1872. One last bridge over the Red, at a location known as Colbert's Ferry, had to be built before the goal of reaching Texas was achieved. On Christmas Day 1872, the Katy steamed into Denison, a new town named for Katy's vice-president, George Denison.

The old Texas Road had given way at last to the era of the railroad. Both river transportation and stage lines quickly waned with the coming of the iron horse. And just as the Five Tribes had feared, the railroad brought even more change to their nations. The tide of non-Indian "intrusion" into tribal lands increased from the moment Elias Boudinot struck the first railroad spike in Indian Territory.

10
OUTLAWS AND LAWMEN

OUTLAW HIDEOUT

Even before the arrival of the railroad, Indian Territory had gained a reputation as a place to flee from authorities. There is little documentation, but some oral tradition says the Indian Nations were a part of the Underground Railroad. The early missionaries were almost all abolitionists and may have assisted escaping slaves in their journeys along the old Texas Road.

The cowboys who traveled through the territory herding cattle were often a rowdy bunch but were not usually given to crime, except perhaps to slipping flasks of whiskey into their boots (bootlegging) to smuggle them into the dry nations. The drovers were more often victims themselves from cattle rustlers and horse thieves.

It was all too easy for the criminal element to slip into Indian Territory, either to commit a crime or to hide out from law enforcement in the surrounding states. The primary reason these conditions existed was the poor way in which the federal government had set up Indian Territory law. Intended to be a home for Native Americans only, the government ignored the fact that many non-Indians lived here or had easy access from the United States.

The tribes moved to Indian Territory were given the authority to police and prosecute only members of their own tribes and only within the boundaries of their own nations. No governmental or police authority existed for non-Indians within Indian Territory.

The result was often chaos. Residents frequently took the law into their own hands because justice could not be obtained any other way. Troops stationed at Fort Gibson and other forts in the territory ended up being the police—working to settle inter-tribal conflicts and keep in check the whiskey peddlers, cattle rustlers and horse thieves who populated the hills and hollows of the region.

After enough complaints reached Washington, the federal court of the Western District of Arkansas was given authority over Indian Territory in 1853. This court, located first at Van Buren and then at Fort Smith, became one of the busiest in the country. But even that did not bring an end to lawlessness in the territory.

After the Civil War, the bitterness and violence that had characterized the conflict continued to inflict wounds on the nation. Bands of guerrilla fighters—jayhawks, baldknobbers and klansmen—continued to fight a war that had not ended for them. Gangs such as the James brothers and the Youngers found safe haven in the hills of eastern Indian Territory.

When the Missouri, Kansas & Texas Railroad entered the Cherokee Nation, it became a new temptation and target for outlaws. In fact, the Katy, because of its route through Indian Territory, was one of the most targeted rail lines in the country. It passed through large stretches of sparsely inhabited land, which made it easy to rob. Gangs were targeting the Katy shortly after it laid the first tracks into the territory.

Trains were derailed or switched and then held up by armed men who looted the express car and strong-armed passengers into surrendering their valuables. The entire route of the Katy through the Indian lands was vulnerable to assault, but the gangs soon learned all the weak points. Locations at Pryor Creek, the Blackstone Switch, Eufaula bottoms, Limestone Gap and the Stringtown Cut were favorite spots for ambush. Mounted gangs could stop the train, ransack its cargo and passengers and then disappear into the hills in a matter of minutes.

Tribal leaders felt continually frustrated with the inability of their Lighthorsemen (the tribal police forces) to make arrests of the white intruders into their nations. Any meeting with U.S. government officials included discussions of how to deter the crime the Katy was attracting. The Native Americans needed recourse, but they did not want to lose any of their sovereignty or the authority of their own courts.

In 1875, the government consolidated the agencies of the Five Tribes into one agency. This Union Agency was located at Muskogee, with its central Katy depot. The Union agent was given authority to address the

The Turner Mercantile in Muskogee sat on the Texas Road and was the scene of Captain Sixkiller's ambush. *Oklahoma Historical Society.*

crime problem. That same year, a new judge was appointed to the bench at the Fort Smith federal court. His name was Isaac Parker. He, too had been tasked with tackling crime in Indian Territory.

Working with the Indian police, the Union agent hired a U.S. deputy marshal named Sam Sixkiller to oversee policing the territory. A Cherokee veteran of the Civil War, Sixkiller moved to Muskogee in 1879 to serve the Union Agency. He was a highly respected lawman and was credited with doing much to curb the lawlessness that had grown rampant in the territory following the Civil War.

Unfortunately, Sixkiller was shot and killed in Muskogee on Christmas Eve 1886 outside the Turner Mercantile on the Texas Road. His murder was thought to be retaliation for a gun battle in Muskogee that had taken place earlier that year. His death highlighted how dangerous the work of a marshal was in Indian Territory. Other shootouts through the years also occurred on the road, including the killing of Marshals Ed Reed in Wagoner and Edward Thurlo in Durant.

THE MARSHALS

It has been said that more marshals were killed along the Katy corridor than in nearly any other location in the United States. Because of that fact, the U.S. marshals are historically most often associated with the federal court in Fort Smith, which had jurisdiction over Indian Territory.

Judge Parker hired a virtual army of deputy marshals to scour Indian Territory for the criminal element. And he prosecuted these criminals to the fullest extent of the law, sentencing over 170 men to the death penalty.

Eighty-eight convicted men were hanged during Parker's twenty-one years on the bench. It earned him the nickname of the "Hanging Judge."

Despite the work of Parker and the marshals who served his court, achieving justice and curbing crime in Indian Territory remained difficult because of the distance to Fort Smith. Residents of the territory asked the federal government for a court closer to them. In 1889, the first federal court in Indian Territory opened in Muskogee. The first U.S. marshal to serve this new court was Thomas B. Needles. Many of the U.S. deputy marshals who had served in Fort Smith were moved to the new court in Muskogee to work for Needles.

These marshals, who included such men as Bass Reeves and James "Bud" Ledbetter, built their own reputations for law and order, as had Judge Parker. They faced dangerous, even life-threatening situations as a matter of course. Many of them gave their lives in the line of duty. In fact, the Katy rail line was referred to as the "dead line." Marshals who crossed it knew they were taking their lives into their own hands. Some, like Reeves, Ledbetter, Bill Tighlman and Heck Thomas, became famous for their brave exploits.

Made equally famous by highly colorful news accounts were the bandits and outlaws who populated the rugged terrain of the Indian Territory. Frank and Jesse James, Cole Younger and his gang, Cherokee Bill and the Cook gang and the Starr family—Tom, Sam and Sam's wife, Belle—were all given cult hero status by salacious newspaper reports and dime novels of the day.

Belle Starr, a native of Carthage, Missouri, had married Cherokee citizen Sam Starr. Because of her association with the infamous Starr family, she was dubbed the "bandit queen" by these writers of western tales. At worst, she and her husband were guilty of stealing horses, but in highly romanticized accounts, she was portrayed as the ruling matriarch of most of the gangs who roamed the hills of the Cherokee, Creek and Choctaw Nations.

One incident with Belle took place at a location that would later be a well-known stop along the Jefferson Highway. Fort Smith court records show that in July 1882, Belle and Sam Starr were charged with stealing a horse belonging to Pleasant Crane. A warrant for their arrests was issued at Fort Smith.

The warrant was sent to L.W. Marks, who was the deputy marshal for the Vinita District of the Cherokee Nation. The warrant shows that Marks did not arrest Sam and Belle Starr until September 1882, nearly eight weeks after the charges were filed. Mrs. Fannie Marks, the deputy's wife, years later told of the arrest of two of Oklahoma's most famous outlaws.

When a deputy marshal set out into Indian Territory to make arrests, he generally would rent a wagon, outfit it with supplies for about a month and hire a driver, cook and guards. Then he would cross into the Indian Country

with a handful of warrants and begin the sometimes tedious job of locating the wanted outlaws. He might ride the Texas Road or even take the Katy to points within the territory.

Commonly, the marshal would set up camp at a central location, form a posse of local citizens, go out, make a few arrests and bring the prisoners back to camp, where they would be guarded and fed. When the marshal had served all the warrants he could, he would then take his group of prisoners back to face charges in Fort Smith.

Deputy Marshal Marks had been trailing Belle and Sam Starr for some time. It had been reported to him that they were heading for the Osage hills to evade arrest. According to his wife's later reminiscences, the Starrs stopped for the night at the home of an African American family who lived on Bird Creek near Catoosa.

The marshal and his men camped on the creek, out of sight. Soon, Sam Starr and one of the boys from the house brought the horses to the creek for water. The marshal arrested and disarmed Starr and then sent the child back to the house. He was to tell Belle that Sam wanted her down at the creek. When Belle approached the creek, she, too, was arrested.

Belle proved to be a loud and unruly prisoner, causing much grief to her guards. As the only woman among the lot of outlaws, she was not chained as the others were. This would prove to be a mistake.

According to Mrs. Marks, the prison wagon camped at Muskogee on the way back to Fort Smith. They were stopped at the Indian Fairgrounds (now Spaulding Park). The marshal and his posse were out making arrests of other criminals, so the prison camp was lightly guarded. They returned to camp at suppertime to find it in an uproar.

Spaulding Park was the site of Belle Starr's attempted escape. The park sits on the old Jefferson Highway in Muskogee. *Author's collection.*

Belle had been eating supper in her tent with a guard seated outside. A gust of wind blew up the tent flap, revealing the guard with his back to her, his holstered pistol within her reach. In a flash, Belle grabbed the pistol and got off a shot, though it did no harm.

The posse returned to find Belle running through the camp in pursuit of the guard, hoping to free all the prisoners. She was quickly recaptured and, for the rest of the journey to Fort Smith, kept handcuffed.

Sam and Belle Starr were tried for horse theft by Judge Isaac Parker, and both were sentenced to serve prison time in Detroit. This was the only crime of which Belle Starr was ever convicted. But to this day, she is associated with many of the gangs who terrorized the trains of the Katy and the citizens of Indian Territory.

Railroad Reaction

In response to constant threat, the railroad hired lawmen to ride the rail line, particularly if a large shipment of money or goods was being transported. In 1894, Bud Ledbetter was hired by an express company to police the railroad. He was on the Katy in mid-November of that year when one of the more famous train robberies occurred.

The year 1894 had seen a great deal of outlaw activity. It was during this time that the U.S. government made a large payment to Cherokee citizens for the purchase of the Cherokee Strip—a northern section of land along the Kansas border. With so much money being transported and changing hands, bandits saw an opportunity for easy spoils.

Such rich pickings attracted an outlaw known as "Texas Jack" to Indian Territory. This outlaw, whose given name was Nathaniel Reed, had spent most of his adult life robbing banks and stagecoaches in Texas, Missouri and Colorado. Though he never killed anyone, he was not averse to carrying an arsenal of guns and threatening their use in his many robberies.

Texas Jack and Bud Ledbetter were destined to meet when Reed attempted to rob the Katy Flyer on the night of November 13. Ledbetter and three other law officers were riding the train that night. The Katy had boarded passengers in Muskogee on the northbound train. There was an express car—carrying money no doubt—plus three passenger cars and a sleeper.

It was a common practice among would-be train robbers to "switch" a train to a side rail at some dark and isolated location. About eight miles

north of Muskogee, near the community of Wybark, was the Blackstone Switch. Here was where Texas Jack attempted to waylay the Katy Flyer.

However, the alert engineer saw the switch turn from red to green and recognized what was happening. He set the brake to slow the train down and then threw it into reverse, causing the train to stop short of where Jack and his gang waited. It also threw the passengers about and awakened all who had been sleeping.

A gun battle ensued, and Ledbetter and the other lawmen were able to keep the robbers from reaching the express car. Texas Jack did, however, manager to board a passenger car and rob its occupants. He made his way through all the passengers, but upon reaching the express car, he was promptly shot by Ledbetter.

One of his gang members helped him get away, but he nearly died from the wound. It was while he was recovering at his brother's home in Arkansas that Texas Jack repented of his outlaw ways. He surrendered to federal marshals and was sentenced by Judge Isaac Parker. After serving a short prison term, Reed joined a Wild West show and went on the lecture circuit, declaring to his audiences that crime doesn't pay.

Another train robber whose reputation exceeded his actual exploits was Al Jennings. Like many others of his day, Jennings operated on both sides of the law during his time in the Twin Territories. He was born in Virginia in 1863 and given the name Alphonso. A Shawnee newspaper stated in an article in 1902 that he cut off the last two syllables of his name to keep them from being shot off when he arrived in the territory in the early 1890s.

Jennings practiced law for a time before becoming disillusioned with the judicial system. He turned to a life of crime with his brother Frank and two Irish brothers named Patrick and Maurice O'Malley, and they became the Jennings gang.

The Jennings gang built its reputation as train robbers, though there are wildly different claims about the success of its villainy. Its crime spree covered only a few months in the summer and fall of 1897. But it was enough to warrant a large reward for the gang's capture.

In late November 1897, deputy marshals converged on the Spike S Ranch, where the Jennings gang was hiding. In the ensuing gunfight, Al and both the O'Malley brothers were wounded, but not seriously. Jennings was shot in the leg. They were able to slip away from the ranch, however, and made their way south through the Creek Nation.

Deputy Marshal Ledbetter tracked them in the intrepid fashion that had built his reputation. Often referred to as a "bloodhound," Ledbetter was

known to stay on the trail of an outlaw for days and even weeks, and he rarely failed to make an arrest.

Ledbetter caught up with the Jennings gang at Carr Creek, near Onapa on the Texas Road in McIntosh County. Some reports say he captured the gang singlehandedly without firing a shot. He brought them to the federal prison in Muskogee.

Al Jennings was tried and sentenced to life in prison, but his legal connections enabled him to get a much-reduced sentence of five years. After he got out of prison, Jennings returned to practicing law, wrote a book of his life story, went on the lecture circuit, did a little preaching and even ran for governor of Oklahoma. He then felt the call of Hollywood and moved to California, where he spent his later days making movies and spinning tall tales about his life in Oklahoma.

THE GANGSTER ERA

Even into the 1920s and 1930s, after the Jefferson Highway had been constructed, the railroad and highway were frequented by the criminal element. The Cookson Hills gang, Pretty Boy Floyd and the infamous Bonnie and Clyde were all operating in Oklahoma during the days of Prohibition and the Depression.

Bonnie Parker and Clyde Barrow, in particular, kept the highway hot in their spree of robberies and shootouts in the early 1930s. Between their hometown of Dallas and their preferred hideout in Joplin, Missouri, the pair frequently drove through Oklahoma, evading the law and striking fear in citizens along the route.

Bonnie and Clyde, along with various associates who made up their gang, were responsible for the deaths of two Oklahoma officers of the law between 1932 and 1934. They shot and wounded the Atoka County sheriff and killed his deputy, Gene Moore, at a dance in Stringtown. Later, they killed Constable William Campbell and kidnapped the Commerce police chief, taking him up toward Baxter Springs, Kansas, before releasing him.

Most of the Depression-era outlaws were killed in shootouts somewhere other than Oklahoma, but they have long been associated with the still wild ways of the Indian Nations. Their dreadful crimes made the old road a fearful place for a time, but today their stories add to the character and mystique of the Jefferson Highway.

INDUSTRY AND ENTERPRISE

The Fur Trade

While the road that would become the Jefferson Highway had its moments of war and criminal activity, it was more often a route of industry and enterprise. From its beginnings as a hunting trail, the road was traveled by those men and women who sought a good life for themselves and their families.

The Osages gave the trace its name and used it to trade with the French and American fur traders who set up posts where the rivers and the road crossed. At Three Forks and North Fork Town, fur trade communities were the first semblance of towns along the road. Fur trading is known to have been an industry in Indian Territory from as far back as 1796.

Following the Civil War in Indian Territory, merchants and traders moved into the region in greater numbers than ever before. One such trader was Joseph Sondheimer, a Jewish immigrant from Bavaria. Sondheimer had opened a hide and fur business in St. Louis just before the outset of the war. During the war, he supplied the military at commissary stations he established along the Mississippi River at locations such as Cairo and Memphis.

In 1866, Sondheimer made a horseback trip through the Indian Territory and liked the potential for trade he found there. Using his military connections, he opened small trade depots along the military road that ran from Fort Scott, Kansas, to Fort Gibson and on to Jefferson, Texas. He traded primarily in hides, furs and pecans.

The Three Forks area became his central distribution point because the Texas Road crossed the navigable Arkansas River here. Sondheimer began shipping tons of hides from cattle, buffalo and deer, as well as furs, wool and thousands of pounds of pecans, to eastern markets and Europe.

Unlike many traders in the territory, Sondheimer did not barter for the hides and furs he obtained. He paid the Indians who brought in these goods in gold coin. It is said that he was respected and trusted by the Indians, and though he often carried large amounts of cash while riding his big white horse through the territory, he was never once robbed.

In 1867, Sondheimer built a large warehouse at the Creek Agency located near Fern Mountain, across the Arkansas River from Three Forks. The agency site was a natural choice for a trading location because the Creeks visited there frequently in conducting their business with the government. Soon, other traders were also building around the agency, and a little community developed there.

When the Missouri, Kansas & Texas Railroad established its Muscogee Station in 1872, Joseph Sondheimer and most of the other businesses at Creek Agency moved to the depot site, forming the core of the new town of Muskogee. For years, well into the 1940s, the Sondheimer family continued to be a major exporter of furs and hides. And for many of those years, Joseph Sondheimer had made his circuit between St. Louis and Texas on the fur trading road.

Salt Mining

Besides the fur-bearing animals, there was another natural resource that drew people to northeastern Oklahoma: the abundance of salt springs that existed for centuries in this region. Native Americans mined the salt from these springs and used it not only for preserving food but also as a trade commodity—first traded with other tribes and then with the French, Spanish and English.

Salt mining could be considered Oklahoma's second industry, developed long before Indian Territory was established. A salt mining business existed at a spring just east of the Osage Trace, near Mazie, before 1820. It was called the Neosho operation and was run by two partners, but little else is known about it. By the time the Union Mission was established near the Mazie spring in 1821, the Neosho operation was already out of business.

Two brothers named Richard and Mark Bean purchased the salt kettles from the Mazie spring and set up a saltworks of their own on a spring near

the Illinois River in 1820. Their tidy little farm, being one of only a few in this area at that time, was frequently visited by explorers to the region.

The Beans built a springhouse and furnace near the salt spring. Using large iron kettles, they would boil the water from the spring until it had evaporated and the salt was left. The Beans could get a bushel of salt from fifty-five gallons of saltwater. They would sell the salt for one dollar per bushel, and the military posts at Fort Smith and Fort Gibson were their primary customers.

The Beans were forced to give up their saltworks in 1828, when the land they had settled was given to the Cherokees by the federal government. All whites in the area were required to leave, and as compensation, they were given land in Arkansas Territory. The Cherokee Nation then gave the Beans' saltworks to a tribal member.

Another large saltworks utilizing the Texas Road was operated by a man named Mackey. His operation was about seven or eight miles farther upstream from the Beans (about ten miles from present-day Gore). Like the Beans' operation, Mackey's farm was also a major stopping point on the military road between Fort Smith and Fort Gibson.

This patched salt kettle from Mackey's saltworks was used for many years after the Civil War. *Author's collection.*

The Mackey saltworks continued operation until 1864, when it was destroyed by Federal troops to prevent its capture by Confederates. After the war, the kettles were patched and used by local Cherokees. One of the huge iron kettles from Mackey's saltworks can still be viewed on the campus of Bacone College on the Jefferson Highway.

COTTON WAS KING

When the Five Civilized Tribes were removed from their homelands in the southeastern states to Indian Territory, they brought with them their southern way of life. Many had owned large plantations and kept slaves for the production of cotton, which was very labor intensive. They brought this practice to the Three Forks area, and the rich river bottomland soon was settled with cotton plantations.

Cotton production grew in the area until it was devastated by the conflict of the Civil War. Following the emancipation of slaves, many of the freedmen slipped away from their former masters, who had taken them to Texas, and they returned to the homes they had known on the river plantations. These freedmen settled into cotton production, as did many white tenant farmers who moved into the territory when the railroad arrived. Cotton was a major crop on farms along the Katy Railroad for many years.

Cotton was not a wildly profitable crop because it required so much hand labor. By the time the landowner had paid his laborers and his creditors—for he always had to borrow against the crop—he rarely did more than break even. But cotton production employed hundreds of workers, and it propped up the local economy with those jobs.

Besides the planting and harvesting of cotton, gins and mills to process the cotton and cottonseed were also major employers in the area. Almost every community in Indian Territory had at least one cotton gin located somewhere near the railroad tracks that passed through town. Some larger towns like Muskogee, Vinita and Atoka had several gins.

In 1899, the Patterson Cotton Gin, one of Muskogee's largest, handled 4,380 bales of cotton, bought from farmers who came from all over the region. It paid out over $65,000 to cotton farmers for their product that same year. During the harvest season, the cotton gins would run night and day, compressing the fleecy product into bales to be shipped out on the railroad to markets all over the world.

The gins extracted the cottonseed from the bolls, and this byproduct provided employment in a secondary industry. The Muskogee Cotton Oil Mill Company

Tons of cotton were produced and shipped along the Katy rail line well into the 1950s. *Oklahoma Historical Society.*

was a leading industry in Muskogee around the turn of the last century. Employing over sixty men, this mill paid out $100,000 for cottonseed in 1899 and had a capacity of sixty tons of crushed seed per day. The oil was shipped out in tankers, and the crushed seed was sold to local stockyards for cattle feed.

But cotton did not remain king in the Three Rivers region. Several factors played a role in eventually ending the cotton industry in Oklahoma, including the depressed prices during the 1930s and the rise of synthetic fibers after World War II. But even as late as 1955, the newspapers reported that nearly 27 percent of Oklahoma farmland was still in cotton production.

By the late 1950s, the land was exhausted, and the boll weevil had become too destructive. Farmers either abandoned their land and moved away or switched to the production of more profitable crops such as wheat, corn or soybeans. Much of the land was returned to the native prairie and used as range for cattle.

A STABLE BUSINESS

The American West could not have been tamed and settled without the hardworking horse. Few other means of travel were as dependable, and this was especially true in Indian Territory. For hauling freight, mules joined horses in traversing the Texas Road across the Indian Nations.

Steam-powered transportation such as steamboats on the Arkansas River and the sole railroad through Indian Territory, the Katy Flyer, brought people to port and depot towns. But once those people arrived, they needed a horse, or horses, to get around this vast but sparsely populated region.

Usually, a livery business or wagon yard was one of the first businesses to be established in any town, no matter what its size. Livery stables provided customers with horses for rent, as well as wagons, buckboards and fancy leather-trimmed surreys. As more and more non-Indians streamed into Indian Territory, the livery stable and wagon yard did a lively business.

Livery stables also boarded horses for individuals who did not have stables of their own. Many new arrivals to Indian Territory would spend their first years here living in a boardinghouse or hotel. They would have to board their horses as well, and the livery stables provided for the care and feeding of hundreds of horses each year.

For folks traveling into town from the farm for market day, a wagon yard was the equivalent of an RV campground today. Farmers would park their wagons and pay for their horses to be watered and fed while the family took care of business in town. If the journey home was too far to make in a few hours, the family would spend the night sleeping in the wagon and then set out for home the next day.

This restored Phillips 66 Station sits on the old alignment of Highway 69 in Old Town McAlester. *Author's collection.*

Eventually, the livery stable became obsolete, as the automobile replaced the horse for transportation. Many livery businesses gradually shifted to become automotive service stations. The Jefferson Highway was lined with the old liveries turned into gas stations, and many of these beautiful old relics of the past can still be seen along the road.

WORKING IN THE COAL MINES

In its early years, the Missouri, Kansas & Texas Railroad relied on interstate traffic, shipping Texas cattle north to meat plants and carrying grain crops from Kansas to the Gulf. With time, the farms and ranches of Indian Territory slowly began to contribute both cattle and cotton to the Katy's shipping manifests.

But Oklahoma's abundant underground resources were tapped in the decades just before and after statehood in 1907 and provided a wealth of product for shipment on the railroad. The Katy's monopoly as the one major rail line in Indian Territory paid big dividends for its owners and investors.

Oklahoma is included in the large swath of coal veins in the American heartland. These pockets of rich bituminous coal are found in the old Indian Territory part of the state, close to and right on the Katy rail line. The development of Oklahoma's coal industry is largely attributed to the enterprise of merchant James J. McAlester.

McAlester, a Civil War veteran, operated a trading post at the Cross Roads near Perryville in the Choctaw Nation. He had learned about vast coal deposits from a fellow soldier who had mapped the area before the war. After settling in Indian Territory, he married a Choctaw woman, which gave him access to land. He located a vein of coal and filled a wagon with the black ore.

Learning that the Missouri, Kansas & Texas line was building south into the territory, he knew he would find in it a customer for coal. He hauled his load of coal to Parsons, Kansas, which was headquarters for the Katy. McAlester convinced railroad officials to place a depot near his store with its easy access to the rich coal deposits. When completed in 1872, Katy obligingly named this depot McAlester.

By 1873, the first commercial coal operation had begun, and over the next decade, the Katy and other holdings of Jay Gould had a monopoly on coal production in Indian Territory. The Katy either owned or held a large interest in mining operations near McAlester, Krebs, Savanna and Atoka, all towns along the Texas Road.

Rail cars loaded with coal sit at Stringtown, a community in the heart of the coal mining district in the Choctaw Nation. *Author's collection.*

In the 1880s, coal production rose from 150,000 tons a year to over 600,000 tons annually. With additional rail lines allowed in the late 1880s, the Katy and several short lines built a network to haul coal from the rich deposits of Indian Territory. Most of these rail lines owned the coal mines that employed hundreds of European immigrants located in the hills of eastern Oklahoma.

Coal production continued to rise every year into the 1920s, when the Jefferson Highway was being paved alongside the Katy Railroad. It lagged during the Depression but increased again for World War II. After this war, new deposits were discovered along the northern stretches of the Jefferson Highway, near Vinita. Over 200 million tons of coal have been mined, and much of it was used or hauled to other markets by the Missouri, Kansas & Texas Railroad.

THE OIL BOOM

Where there is coal, there is also oil, and in Oklahoma that is certainly true. Native Americans had used the natural "seeps" of oil for generations, but it was primarily considered to have medicinal uses until Edwin Drake drilled the first commercial oil well in Pennsylvania in 1859.

In Indian Territory, members of the Five Civilized Tribes were aware of oil's existence in their nations, but without efficient ways to extract it, or a demand for it, there was little interest in drilling wells until the age of the automobile. Beginning in 1891, Indian Territory saw the tiny beginnings of the oil boom. It was in that year that Congress allowed mineral rights to be leased on Indian lands.

There are differing accounts about where the first oil well was drilled in Indian Territory. One source says that Lewis Ross was digging a salt well at Salina in 1859 and hit oil instead. His well produced about ten gallons of oil

a day for about a year. Another source says a well near Wapanucka in Atoka County was the first, dating to 1875. How much it produced is unclear. Still another source states that the first "deep" well was drilled in 1884 near Atoka.

In 1895, the Creeks agreed to allow oil drilling in their nation, as long as the drilling venture included three Creek citizens. A group of investors—three Creeks and three other men—incorporated the Creek Oil and Gas Company in September 1895. They undertook their first effort by attempting a well in Muskogee, east of the Katy tracks, on land owned by Creek citizen Frederick Severs. This well struck oil at 1,200 feet in November 1896.

Production was limited, however, because they did not have the facilities to store or ship the oil. Another well was drilled in Muskogee in 1903, and it came in as a gusher, spewing oil on nearby homes. This set off a frenzy of drilling.

Soon, a "forest" of oil derricks was cropping up south of Muskogee. This brought the attention of refiners, and Oklahoma's first oil refinery was established. The Muskogee Oil Refinery produced kerosene, lubricating oil and industrial fuel beginning in 1905. There was, as of yet, no great demand for gasoline, but that would quickly change as the automobile became more affordable and readily available.

By the early 1900s, oil and gas production was spreading along the Katy corridor as more investors put money into oil exploration. By this time, Oklahoma's oil boom was in full throttle.

Like the gold rush of earlier years, the oil rush brought thousands of investors, speculators and wildcatters to the state. In April 1901, one of the wealthiest women in America visited Wagoner because she had heard that oil had been discovered in the area. Hetty Green was an investment mogul who had inherited $1 million from her father and turned it into hundreds of millions of dollars during her lifetime.

She traveled to Indian Territory by a special Katy rail car to investigate the investment opportunity in oil. Her visit brought out the curious to see

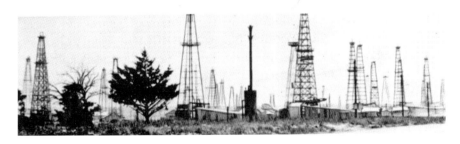

A forest of oil derricks, such as this field, was a common sight in the early oil boom days of Oklahoma. *Oklahoma Historical Society.*

this eccentric woman who had earned the nickname the "Witch of Wall Street." She was known for her stinginess rather than unethical dealings.

Green apparently was not sufficiently impressed with oil in Oklahoma to put her carefully guarded funds into the largely speculative industry. But others, such as J. Paul Getty, Harry Sinclair and Frank Phillips, made their fortunes in Oklahoma, and all left their names on the oil industry.

LEAD AND ZINC

Other minerals have been mined along the Jefferson Highway as well. The wealth generated by the coal industry was later eclipsed by the lead and zinc production of far northeast Oklahoma.

The first town encountered by travelers following the Jefferson Highway south from Baxter Springs is the small community of Quapaw. Named for the Quapaw tribe, this town was once known as the hay capital for the large amounts of hay shipped out from its depot. Its economy is still tied to ranching today. But its greatest riches came from the mines below the lands allotted to the Quapaws.

In 1904, the Dark Horse Mine began operations near Quapaw. It was followed by many others in the tri-state region of Oklahoma, Missouri and Kansas. New towns on old stretches of the Shawnee Trail sprang up as hundreds of miners moved into the area. During World War I, these mines produced half of the world's supply of these two ores.

The towns of Picher, Commerce and Miami all prospered from the mines and from ancillary businesses that supported mining operations. Individual mine owners and investors made their fortunes from the Picher Mining Field. Wonderful old buildings such as the Coleman Theater, sitting on the Jefferson Highway in Miami, were built with money from the ore.

After World War II, production decreased, but even so, nearly $20 billion had been generated from the mine fields through which the highway passed. Huge chat piles from the mines can still be seen from the highway today, but mining has ceased, and cleanup of the old fields is an ongoing effort.

From its beginnings, the Jefferson Highway, in all its various forms and names, has been associated with the wealth of eastern Oklahoma's natural resources. When the state was still two territories, it is no wonder that business leaders and politicians in the western Oklahoma Territory wanted to "marry an Indian" to gain access to the riches in the land of the Five Tribes.

TRANSITIONING TO STATEHOOD

COURTS AND LAND RUNS

The move toward Oklahoma's statehood was slow and often rancorous. As with other issues, the members of the Five Tribes were divided on the statehood issue. Many mixed-blood and intermarried Indians wanted statehood and the advantages that would come from belonging to the Union. Many full-bloods and freedmen were suspicious of the federal government and wanted to retain tribal sovereignty.

A series of events brought Indian Territory ever closer to statehood despite stiff (even armed) resistance at time from tribal members. The Five Tribes had tolerated the federal presence at the Union Agency because annuity payments were tied to the agency. They begrudgingly accepted the Katy Railroad even though they watched in dismay as it brought in hundreds and then thousands of non-Indian settlers.

The tipping point in favor of statehood came in 1889, when two important events occurred on the same day. First, the federal court opened its first session in Muskogee on April 22 in a building near the Katy tracks. A few hours later, the Unassigned Lands, also called the "Oklahoma lands," were opened in the first of several land runs that would flood the territory with newcomers.

A debate had raged for a decade about the Unassigned Lands in the center of Indian Territory, and it centered on two special interest groups. The railroads, led by men such as Jay Gould, wanted the land opened for settlement. A rail line had been built through the area in 1887, but

with a sparse population, there was no money to be made on freight and passenger services.

Seeking potential customers, the railroad men and their attorneys argued for opening the land to settlement. They contended that the Unassigned Lands were public land and therefore fell under the Homestead Act, which allowed U.S. citizens to file a claim, improve the property, live on it for five years and then own it free and clear.

But Congress repeatedly resisted efforts to open the land for settlement. Some critics said that wealthy cattlemen were behind this reluctance. They leased the open range of the Unassigned Lands for their large herds and did not want it broken up into farms with fences.

Legally, the issue was just as confused as all the arguments and the special interests behind them. The Creeks and Seminoles had ceded the Unassigned Lands to the government in the Reconstruction treaties following the Civil War. They were to be paid for the land but had never received that payment. For many years, they refused to negotiate a price for the land, effectively holding it closed to non-Indian settlement.

But a severe drought and other difficulties left the Creeks strapped for cash. In January 1889, they agreed to a price of $1.25 per acre. The Seminoles entered into the same agreement, and it was ratified by Congress on March 1, 1889. Now the way was cleared for the land to be thrown open to settlement, and an amendment doing so was hastily attached to the Indian Appropriations Bill, which Congress passed on March 3.

President Benjamin Harrison set the date for the opening of the Unassigned Lands. For the next few weeks, citizens from all across the western states made their way to Indian Territory and massed on the boundary line of the Unassigned Lands. Never before had public lands been claimed and settled in such a way—with a land run. Hopeful settlers literally raced to claim a 160-acre parcel of Oklahoma land. With the starting boom of a cannon, the landscape of Indian Territory was forever changed. The prospects for statehood were also set into motion.

A year later, Congress created Oklahoma Territory out of the western half of Indian Territory and attached what today is the Oklahoma panhandle. At the time it was known as "No Man's Land." The settlers of this brand-new territory quickly set up a territorial government and were pushing for statehood within the first year of its existence.

In Indian Territory, federal presence spread. Satellite courts were opened in towns along the Missouri, Kansas & Texas Railroad. Soon, Vinita and McAlester joined Muskogee as court towns, with federal marshals assigned to each one.

ROUGH RIDERS

It was also at these towns that recruitment for a volunteer cavalry took place in 1898. America was using the sinking of the USS *Maine* as a reason to enter into war in Cuba. President William McKinley requested that the four western territories—Arizona, New Mexico, Oklahoma and the Indian Territory—provide troops for this cavalry regiment.

For the first time in its history, Indian Territory officially provided troops to fight for the United States. Troops L and M of the First Volunteer Cavalry included men from such towns as Vinita, Pryor Creek, Muskogee, McAlester and Durant. These young men assembled in Muskogee for a swearing-in ceremony before boarding the Katy Flyer to travel to training camps in San Antonio, Texas. At the Katy depot, two hundred men, many Native Americans, formed two lines on the old Texas Road and took the oath to defend their country and its Constitution.

Once in San Antonio, the First U.S. Volunteer Cavalry quickly became known as Theodore Roosevelt's Rough Riders. Roosevelt had resigned his position as assistant secretary of the navy to serve as lieutenant colonel in this regiment. After weeks of intense training, they shipped out to Cuba from Tampa, Florida. Though they were technically not yet citizens of the United States, these troops joined the other territory volunteers and the Tenth Cavalry (a black unit known as the Buffalo Soldiers) in Cuba.

Milo Hendricks, a Choctaw student studying at Henry Kendall College in Muskogee, became Indian Territory's first casualty in the brief war. His death and the service of the other soldiers brought a level of American patriotism to the Five Tribes that had never been felt before.

THE DAWES COMMISSION

During this time, the government had been working to dissolve tribal sovereignty as a way to press the tribes to choose statehood. In 1887, Congress passed the Dawes Act with the intent of ending the communal land system among the Native American tribes in Indian Territory.

The goal was to better assimilate Indians into mainstream American culture and make statehood more attractive. To achieve this goal, the lands held in common by the tribes would be distributed to individual members of the tribe. Then, tribal governments could be dissolved.

At first, the Five Civilized Tribes and the Osages were exempted from the allotment program, and for several years these tribes successfully resisted all efforts to move them toward allotments. But as all the western tribes were given allotments and their surplus lands were opened to the land runs, pressure increased on these last remaining tribes to also accept allotments.

In 1893, Congress formed a commission—named the Dawes Commission after its chairman, Henry Dawes—to negotiate with the tribes that now made up Indian Territory so allotments could begin. The commission chose Muskogee as its headquarters, but the three commissioners traveled extensively by train to towns along the Katy rail line to meet with the Five Civilized Tribes.

Tribal members would listen politely as the Dawes commissioners explained all the reasons they should accept allotments. Then, they politely but firmly declined to sign treaties accepting the distribution of their land. Finally, in 1895, Congress authorized surveys of these lands to begin. The intent was clear: allotments would be made; it was just a matter of time. The following year, Congress passed an act to begin enrollment of all tribal members.

The Dawes Commission worked tirelessly for four years before the first allotment treaty was signed by the Choctaws and Chickasaws in 1897. The Atoka Agreement, as it was called, provided that Indian courts would be dissolved, tribal members would be enrolled, allotments would be made and tribal governance would end. Tribal governments would continue until 1906, at which time they would be dissolved. Treaties with the Cherokees, Creeks, Seminoles and Osages followed.

The Dawes Commission then had the incredible task of surveying, appraising and allotting the twenty million acres of land lying along the old Texas Road corridor in the eastern half of Oklahoma. Hundreds of government workers came to Muskogee to help with the task.

Over 250,000 people flooded into the territory, all claiming to be Indian and entitled to land. Dawes Commission workers had to interview each one and examine any documentation they provided as proof. Nearly 104,000 names were placed on the tribal rolls, including freedmen from each tribe.

THE CURTIS ACT

While the Rough Riders were fighting in Cuba, the Atoka Agreement was being made law as the Curtis Act in June 1898. This bill was sponsored by Kansas senator Charles Curtis, of the Kansa tribe. With

the passage of this law, Congress took control of the laws and affairs of Indian Territory.

For the first time, under this act, towns in Indian Territory could actually be surveyed and incorporated. Municipal governments could form and provide for such services as water and sewer, paved streets and public schools. None of this had existed before 1898.

There had been few, if any, paved streets or roads in Indian Territory. Maintenance of bridges, fords and ferries had fallen to private individuals, usually authorized by the tribe to which they belonged. Someone would plow fire-break roads around the community to keep prairie fires from reaching the mostly wooden structures that made up the towns. But all other streets were rarely maintained and had never been surveyed or laid out in a grid. Often, these dusty or muddy streets simply meandered to and from the Texas Road or the railroad.

Dozens of Indian Territory towns incorporated in 1898 and held elections for the first time. Now, town site commissions could be formed, lots and blocks surveyed and street grids laid out. Also, for the first time, non-tribal members could own land. More non-Indians flooded the territory; many were land speculators who hoped to profit from this new law.

All of these provisions of the Curtis Act served to weaken tribal governments to mere figurehead or ceremonial status. Statehood was quickly becoming inevitable, and the only question to be decided was what statehood would look like for the tribes of Indian Territory.

THE STATEHOOD DEBATE

As soon as Oklahoma Territory had been established in 1890 and its government put in place, there was talk of statehood for this new territory. The question of whether Oklahoma Territory should be a state separate from Indian Territory was a subject for discussion, not just in the Twin Territories, but all over the United States. The issue was covered in newspapers across the country, and everyone, it seemed, had an opinion in the statehood debate.

Most members of the Five Civilized Tribes did not want statehood of any kind, but in particular, they did not want to be forced into a statehood "marriage" with Oklahoma Territory. Newspaper editorial cartoons portrayed the territories as a willing suitor (Oklahoma Territory) pursuing a reluctant bride (Indian Territory). The Native Americans resented the

implication that Indian Territory needed Oklahoma Territory to take care of it.

As long as the tribes resisted statehood, Congress delayed outright forcing the issue. Several statehood conventions were held both by "single staters" and "double staters," trying to bring consensus on the issue. The first such convention was held in Oklahoma City in 1891. Delegates favored single statehood and sent a formal request for such to Congress.

Opponents of this bill included Five Tribes members Elias Boudinot of Vinita, Arthur McKellop of Muskogee, Roley McIntosh of Eufaula and J.S. Standley of Atoka. A 1901 convention was held in Muskogee favoring double statehood, but its resolutions went nowhere as well.

Congress continued to stall all these efforts, unwilling to violate the tribal treaties and unwilling to separate the territories and admit only Oklahoma Territory to the Union. The federal government was waiting for the Five Tribes to show their willingness to form a state. Until that happened, the two territories would remain uneasy neighbors.

It seemed that everyone had an opinion about statehood for Oklahoma, including the president of the United States, Theodore Roosevelt. In April 1905, Roosevelt was traveling on a special Katy train to a Rough Rider reunion in San Antonio. He would travel through Indian Territory and make stops at all the larger towns along the route, including Muskogee and Durant.

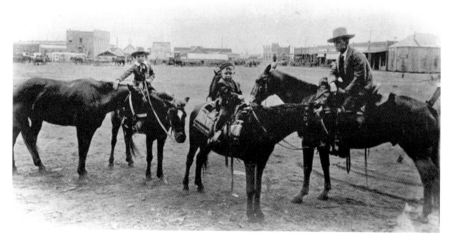

Durant's principal street, like most in the later years of Indian Territory, was dusty and wide to accommodate horsemen of all ages. *Oklahoma Historical Society.*

He arrived in Muskogee on April 6, 1905, expecting to spend just a few moments greeting some dignitaries at the Katy depot. In particular, he wanted to meet Judge John R. Thomas, who had helped to organize the Rough Rider troops from Indian Territory.

Unbeknownst to Roosevelt, a crowd of fifteen thousand people had gathered in Muskogee to see the president. When the train pulled into the station, Roosevelt stepped out onto its rear platform to wave to the crowds. When he saw a speaker's stand built in the middle of Broadway, he ducked back into the car for his silk hat and then stepped down from the train to the Katy depot.

Here, he was greeted by a Muskogee reception committee made up of Judge Thomas, Charles Haskell, Pleasant Porter and others. He was ushered to the podium on Broadway and then introduced to the crowd by Judge Thomas.

In response, the president said, "It is a great pleasure for me to come here and greet you this morning. I have never been in the territory before, but I know your people well. Many members of my regiment came from this very town."

The president went on to compliment Indian Territory and then stated, "Your Territory…in conjunction with Oklahoma Territory will soon be one of the great states of the Union." It was the president's not-so-subtle way of telling the crowd that he favored single statehood, combining Oklahoma and Indian Territories.

Though he spoke for only about ten minutes and his visit lasted only a little longer than that, it had an effect on Indian Territory that Roosevelt certainly never intended. It seemed to have fueled the determination of Indian Territory leaders, particularly the chiefs of the Five Tribes, to try for separate statehood. Within just a few months, another crowd would gather in Muskogee for the Sequoyah State Convention.

SEQUOYAH CONVENTION

In less than a year, on March 4, 1906, all tribal governments would be abolished. It gave a sense of urgency to one more statehood convention held in Muskogee in August 1905. The previous month, four chiefs—Cherokee Clem Rogers, Creek Pleasant Porter, Seminole John Brown and Choctaw Green McCurtain—had called for this convention, with delegates to come from any town in Indian Territory that cared to send them. Chickasaw

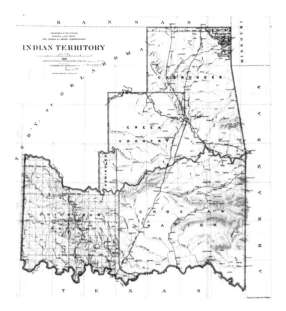

This Interior Department map of Indian Territory shows what the state of Sequoyah would have entailed. *From General Land Office, Interior Department, 1891.*

governor Douglas Johnston declined to be involved in the convention but sent his son-in-law William Murray in his stead.

For days, these delegates arrived in Muskogee on the Katy and checked into the Turner Hotel on Third Street, which was acting as host hotel for the convention. The proceedings themselves took place across Court Street in the Hinton Theater, Muskogee's finest.

Chief Pleasant Porter was elected chairman of the convention. Muskogee businessman and railroad mogul Charles Haskell was vice chair, and Creek editor and poet Alexander Posey of Eufaula served as secretary. Porter made it clear from his remarks that if Indian Territory were to be forced into statehood, then territory leaders would have their say in the formation of that state.

The name chosen for the proposed Indian state was Sequoyah, after the venerated Cherokee linguist. The delegates worked together to hammer out a constitution for their state. It was a thirty-five-thousand-word populist document reflecting the Indians' mistrust of government. When the constitution committee completed its work, the delegates reconvened at McAlester and voted to have Chief Porter and Alexander Posey sign the document on their behalf.

The Sequoyah Constitution was ratified by a vote of Indian Territory citizens in November 1905, and delegates from Indian Territory then delivered it to Congress. Submission of that constitution was exactly what

Congress had been waiting for. At last, the Five Civilized Tribes had signaled that they were willing to accept statehood.

Congress ignored Indian Territory's application for statehood. Instead, it passed the Oklahoma Enabling Act requiring single statehood for the Twin Territories. Without the Sequoyah State Convention, statehood for the combined territories might have been delayed for several more years.

Brand-New State

Shots rang out, church bells sounded and steam whistles bellowed in Guthrie on the morning of November 16, 1907. No longer Guthrie, capital of Oklahoma Territory, the city now was the capital of a brand-new state: Oklahoma! For hours that morning, the early trains had disembarked hundreds of people who had come to the territorial capital to celebrate statehood.

At approximately 10:15 a.m., President Theodore Roosevelt had signed the act of Congress admitting Oklahoma to the Union as the forty-sixth state. With very little ceremony, before a small audience, the president had used an eagle quill pen to apply his signature to the historic document. This event took place in the Cabinet Room of the White House.

Within just a few minutes, a telegram was sent from the White House to Guthrie with the news that Oklahoma was now a state. The secretary to the Oklahoma territorial governor stepped out on the portico of the Carnegie Library, where government officials were gathered, and fired a pistol to alert the city to the news. The new state militia, assembled for the occasion, responded with a volley of its own. Soon, there was chaos in the streets as Oklahomans celebrated the momentous occasion.

Citizens of Indian Territory accepted single statehood as graciously as possible but made sure that their candidate for governor was elected. Muskogee's Charles N. Haskell was to be sworn in as governor at the Carnegie Library on statehood day. But first, an impromptu ceremony took place.

On the steps of the library, a wedding ceremony was conducted, symbolizing the joining of the two territories for life. C.G. Jones of Oklahoma City represented Oklahoma Territory. Claiming to be just eighteen years old (the age of Oklahoma Territory), Jones proposed to Miss Indian Territory. She was actually Mrs. Anna Bennett, a Cherokee woman married to Dr. Leo Bennett, who served as U.S. marshal in Muskogee.

The bride was given away by William Durant, a Choctaw citizen from the city that bears his name. The minister who performed the marriage was Reverend W.H. Dodson, First Baptist pastor from Guthrie. After "tying the knot" and joining the two territories symbolically, Governor Haskell was sworn in at 12:20 p.m. on November 16, 1907.

While the mood was jubilant in Guthrie on this day, the same could not be said for many residents of the new state. Native Americans now saw the sovereignty of their nations dissolved with statehood. Though tears were shed over the passing of the old way of life, these Indians resolved to build a great state, one that would preserve its Native American heritage and history.

THE BLACK TOWNS

UNIQUELY OKLAHOMA

An equally interesting and unique part of Oklahoma's history is that of the African Americans who built their homes and communities along the old Osage Trace corridor. From the time of the fur trade, blacks were contributing to the development of Oklahoma. They came in larger numbers with the removal of the Five Tribes, making the long Trail of Tears journey both as free and enslaved individuals.

Oklahoma's history is unique, particularly in the number of historically black communities that sprang up following the Civil War and continued to grow and develop almost to the Great Depression. At one time, there were around fifty "all-black" towns in the Twin Territories of Oklahoma and Indian Territory. More than half of these communities were formed in Indian Territory, and several still exist along the Jefferson Highway today.

The first towns were established in the Creek Nation by tribal leaders. The treaties of 1866, signed by the Five Civilized Tribes, freed their slaves and gave them citizenship. The Creeks established four towns for their freedmen citizens: Marshalltown, Arkansas Colored, Canadian Colored and North Fork Colored. These towns were political districts as much as actual locations, giving freedmen a means of voting and having representation in the Creek legislature.

Other all-black towns developed after the Civil War, when the newly freed slaves returned to the lands they had farmed since the removals.

They established new farms and built new homes close together for mutual protection, educational opportunities and cooperative enterprises.

Many of the black soldiers who had served during the Civil War and had been garrisoned at Fort Gibson chose to settle in locations around the fort and the supply depot at Honey Springs. Others reenlisted in the black regiments of the Ninth and Tenth Cavalry and Twenty-Fourth and Twenty-Fifth Infantry. Known collectively as "Buffalo Soldiers," these men occupied forts in the Twin Territories and helped to protect the cattle trails and the railroads. Their families also settled in or near the fort communities.

EDUCATION

Some of the mission schools that had closed during the war were reopened to offer education to freedmen children. Tullahassee Mission became a school for Creek freedmen. The Union Agency building was used as a school for African American boys and girls for a time.

Tullahassee Mission was a joint effort of the Presbyterian Board of Foreign Missions and the Creek Nation. It was established in 1849 by Reverend J.M. Loughridge, who also ran the Koweta Mission. William Robertson arrived from New York that year to take charge of the school, but first he had to complete the three-story brick structure. The school housed forty boys and forty girls of the Creek Nation.

The location of Tullahassee Mission was on an offshoot of the Texas Road that ran from Three Forks southwestward to the Creek Agency near Fern Mountain. This much-traveled road meant Tullahassee Mission was a frequently visited rest stop for travelers. Today, the town of Tullahassee sits just off Highway 69, north of Muskogee.

The mission continued in operation until the main building was destroyed by a fire in 1880. Robertson died a few months later, and though his widow and daughter Alice tried to keep the mission running, their efforts proved difficult.

The land around the mission was largely occupied by Creek freedman who had settled there following the Civil War. The Creek Nation made the decision to turn the school into one for its freedmen citizens. A town developed around the mission school, and it gained a post office in 1899. A spur of the Missouri, Kansas & Texas Railroad helped the town to grow. Tullahassee was incorporated in 1902, after most of the land was allotted to freedmen.

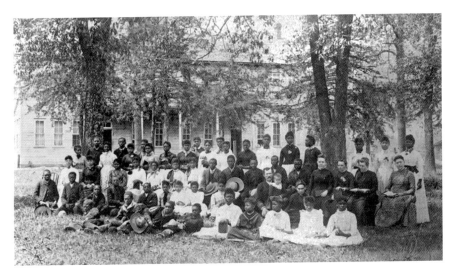

Students and staff pose at the freedman school in Tullahassee, considered the oldest all-black town in Oklahoma. *Oklahoma Historical Society.*

The little farming community supported several businesses and churches. The Tullahassee Townsite Commission advertised the town throughout the South, inviting African Americans to settle there, and this brought several new residents.

At its peak, Tullahassee had about two hundred citizens within its incorporated limits, but the school served a larger area. In 1916, the old mission school was converted to a private institution and named Flipper Davis College. It was operated by the African Methodist Episcopal Church. This school was, for many years, the only private school of higher education for black students in Oklahoma. The college continued to operate in Tullahassee until difficult economic times caused it to close in 1935.

Today, Tullahassee remains one of thirteen all-black towns still in existence. With its roots in the Tullahassee Mission, dating to 1850, this small community has the distinction of being the state's oldest black town.

RAILROADS

When the Missouri, Kansas & Texas Railroad built across Indian Territory in 1871–72, the workers established a depot at a site north of the Verdigris River and northwest of Fort Gibson that quickly gained the name of Gibson Station. Passenger service began from this station in September 1871.

Like all the other railroad terminus towns, Gibson Station earned a reputation for being a wild and wicked place. This condition was worsened by the fact that the town remained the "end of the line" for a much longer period than other terminuses.

Gibson Station was the only depot in Indian Territory for long months while the two bridges were being built across the Verdigris and Arkansas Rivers. It had plenty of time to attract all the usual rowdies drawn to railroad camps.

One of the bridge builders for the Katy was a man named George Shannon. Born and raised in Tennessee, Shannon enlisted in the Union army during the Civil War and was put to work building bridges that had been destroyed in the conflict.

With this experience, the young carpenter moved to Kansas after the war ended and went to work for the Union Pacific Railroad. In 1869, Shannon was transferred to the Missouri, Kansas & Texas line and continued with the railroad as it slowly progressed across Indian Territory. He had a hand in building both the Verdigris and the Arkansas River bridges.

While working in Indian Territory, Shannon met and married Mary B. Willison, a Creek descendant of Muscogee leader William McIntosh. They decided to settle in Gibson Station. Shannon bought a residence and mercantile in the little community. The store operated under his wife's name—M.B. Shannon Mercantile—because she was a Creek citizen and therefore did not have to pay a license fee to the nation.

By this time, the town had mostly shed its wild and wicked ways. George and Mary Shannon prospered in the little community that served as the railhead for passengers in the area. It was not uncommon for several dozen area residents, mostly blacks, to descend on Gibson Station whenever a train was scheduled to arrive. Many came to send out freight or welcome travelers, but just as many came to enjoy the spectacle of the smoke-belching steam engines pulling into town.

The Shannons did a great deal of trade with area freedmen and Indians, taking in large quantities of furs, pecans, honey and wild fruits. They sold the furs to Joseph Sondheimer in Muskogee, who shipped them on to St. Louis and New Orleans.

As the Katy expanded, Gibson Station lost its prominence as a passenger depot, and the town lost most of its residents, who moved on to Wagoner or Muskogee. Today, it is a quiet little community on the old Jefferson alignment and is counted as one of the oldest of Oklahoma's black towns.

Other Katy (now Union Pacific) railroad towns include Wybark, near Gibson Station, and Summit, which sits just south of Muskogee at the

St. Thomas Primitive Baptist Church in Summit is listed on the National Register of Historic Places. *Author's collection.*

highest point along the Katy line between the Arkansas and Canadian Rivers. These two black towns still exist today and still see trains pass through on a daily basis.

ALLOTMENTS

Allotments were another factor that helped create the all-black towns. The freedmen tribal members often took their allotments near one another since every family member would receive land. This is also why the vast majority of the all-black towns are located in the Creek Nation. The Creeks offered their freedmen tribal members 160 acres of land rather than the smaller allotments available from the other tribes. If a freedman had a choice of tribes to enroll with, naturally he would choose the Creek Nation.

These allottees formed agricultural centers where a cooperative cotton gin and gristmill formed the nucleus of the new towns. Soon, they were

117

supporting churches, schools, banks and numerous small businesses. The all-black town offered to African Americans the advantages of reliance on neighbors, financial assistance and a ready market for produce and services without prejudice or discrimination.

The town of Rentiesville was established by William Rentie in 1905 on the freedman allotments of the Rentie family. It sat on the Katy Railroad, within the old Civil War battlefield of Honey Springs, and it flourished in the days of segregation. Buck Franklin, a lawyer of Chickasaw and African American heritage, settled his family here, established his legal practice and served as justice of the peace.

His son John was born at Rentiesville in 1915, and he spent the first ten years of his life in this quiet McIntosh County town. Surrounded by this community of color, John had little experience with the injustices of segregation in his early life. But at age seven, an experience would change his perception of the world and set his course in trying to change that world.

The Franklins would often travel to Checotah to do their shopping, and one day in 1922, they flagged a Katy train passing through Rentiesville. Climbing aboard the passenger train, they entered a car that was reserved for whites. John's parents felt very strongly that they must never voluntarily submit to segregation. So, Mrs. Franklin, John and his sister took a seat in the car. When the conductor told them they would have to leave the car, Mrs. Franklin refused. So the conductor stopped the train and put them off. They had to walk back to Rentiesville.

John Hope Franklin points to this moment as a pivotal one in his life. He would face other incidences of segregation and racism, but this one stirred the first embers of his determination to stand against prejudice and injustice.

The Franklins moved to Tulsa in 1925 because Buck Franklin found it difficult to make a living in little Rentiesville. John graduated from Booker T. Washington High School as its valedictorian and went on to further his education at Fisk University in Tennessee.

For his thesis, John turned to a little-studied aspect of American history: the history of African Americans. His research would later lead him to write *From Slavery to Freedom*, a book that has sold over three million copies and has been translated into several languages.

John Hope Franklin introduced America to black history in a fair and dispassionate work that continues to be honored today. It made him the most celebrated American historian, having received 105 honorary degrees from colleges and universities around the world.

The Down Home Blues Club has a long history in Rentiesville and now houses the Oklahoma Blues Hall of Fame. *Author's collection.*

Franklin also achieved his lifelong goal at striking a blow against segregation. He served on the team of lawyers and scholars who assisted Thurgood Marshall in presenting the legal arguments against school segregation in the landmark Supreme Court case of *Brown v. Board of Education.*

Today, Rentiesville is known for its blues club and the Oklahoma Blues Hall of Fame, created by another famous resident and musician named D.C. Minner. The town has a tiny population that swells to thousands when its annual blues festival is held.

NEWSPAPERS

Entrepreneurs in the all-black communities started many different types of business, including newspapers. In the years just before and just after Oklahoma statehood, dozens of black-owned and edited newspapers thrived.

Many of these papers advertised throughout the South, enticing black settlers (called state blacks) to come to Oklahoma. Many African Americans came, believing Oklahoma was a new "promised land."

While many of these towns grew organically in the way of any town, some were manufactured for the purpose of enticing more African Americans to settle in the territories. Offers of cheap land and opportunity free of prejudice and persecution brought southern blacks to the Indian Territory to join with other African Americans in building a better life for themselves.

An African American attorney and businessman from Muskogee was a part of this effort. Cornelius Jones owned a large block of buildings on South Second Street in Muskogee and was quite prosperous. In 1906, he purchased the entire town of Chase for $4,000. This small community was located about eight miles southwest of Muskogee.

Jones advertised town lots for sale in the black-owned newspapers mailed all over the South. Inspired, no doubt, by the famed Booker T. Washington, who had visited Muskogee a few months earlier, Jones wanted his town to be an educational center for blacks. The town's name was changed to Beland in 1908, and it flourished for a time but had lost its post office by 1926.

The enterprise of black ministers, teachers and attorneys in Indian Territory was one of the reasons Booker T. Washington visited the area in 1905. In a speech he gave while in Muskogee, the Tuskegee Institute founder praised the efforts of these publishers in spurring education, business development and success in the growing black communities of Oklahoma.

Washington had come at the invitation of Cornelius Jones and other black leaders. His arrival in Muskogee on the Katy Railroad drew a crowd of several thousand from all the black towns in the area to greet him as he got off the train.

The streets around the Katy depot were thick with folks hoping to catch a glimpse of the director of the Tuskegee Institute in Alabama. An outspoken advocate for education for blacks, both in the "normal" and vocational studies, Washington had the respect and admiration of the country. His visit to see for himself the thriving black communities gave an endorsement to the efforts of business leaders to recruit more state blacks to settle in Indian Territory.

One Muskogee businessman named J.W. Adams had served on the board of directors of the Tuskegee Institute. He had written a letter to Washington in May 1905, telling him about the opportunities for blacks in Indian Territory. He wrote, "There is no section of the Country that shows the Negro in business more than the Territory."

Originally, his hosts had planned to have Dr. Washington speak at the Raymond Auditorium in Muskogee, but they quickly realized it was too small to hold the crowd who wanted to attend the speech. With assistance

from the City of Muskogee, an outdoor platform was erected at Second and Okmulgee, a corner right in the heart of the black business district. The city blocked Okmulgee traffic so the crowd could stand in the street to hear Washington's speech.

In honor of his visit, African Americans in Muskogee named their largest cemetery for the noted educator. Booker T. Washington Cemetery sits on Highway 69 today, on the northern edge of town.

Faded Glory

Black towns up and down the Jefferson Highway and just beyond still exist today in all of the old Indian Territory nations. But many have little population, and some are just ghost towns.

This was the fate of many small, rural communities, including the all-black towns, in the years between the two world wars. These agricultural centers depended on cotton and other crops. When the market for cotton was devastated by the Great Depression, these towns suffered in every way.

Population was lost to the cities where non-farm jobs were more readily available. The tax base was hard hit, and towns could not support the infrastructure needed to survive. Railroad traffic dried up, and some lines failed altogether. Many rural towns, not just the black towns, never recovered from the Depression.

Most of the black communities faded away, but others are still in existence and give Oklahoma a cultural richness that other states cannot claim. Today, there are thirteen historically black towns that survive, several of them on the old Texas Road corridor. They remind us of their past glory, when economic and political freedom gave hope and opportunity to their residents.

GOOD ROADS MOVEMENT

Mud and Dust

The Texas Road, in all its different forms over its long history, has always been tied to economic prosperity. Maintenance of the road was not a responsibility the tribes undertook while Indian Territory avoided statehood. The tribes allowed toll roads and bridges in their various nations, and individuals who operated them used the money earned on them to cover maintenance costs.

The first non-railroad bridge across the Arkansas River was built by a private citizen, Homer B. Spaulding of Muskogee, who charged a toll for crossing. Bridges or ferries across the Canadian and Red Rivers also were private endeavors along the Texas Road.

In Oklahoma Territory, the few roads that existed were dismal, and farmers struggled with getting their produce to market. Neither the tribes of Indian Territory nor the territorial government of Oklahoma had the funding to maintain roads, even those well-established thoroughfares like the Shawnee and Chisholm Cattle Trails.

In the first decade of Oklahoma statehood, road maintenance was a county responsibility, and each township within a county (a thirty-six-mile subdivision) was required to grade its own section of roads. Often, this labor was undertaken by local men who might have limited skill in such work.

It is no wonder that residents of the Twin Territories, even before Oklahoma statehood, were clamoring for better roads. One of the greatest complaints that early day residents had about their towns were the streets—or perhaps

the lack of streets. With no city government, there was no authority, and no workforce, to lay out streets or maintain them.

The *Indian Journal* newspaper in June 1883 ran a picture of Main Street in Muskogee and called it a "hog wallow." Unpaved and poorly maintained, the street was full of potholes that filled with mud in wet weather. Wagons could easily get stuck in the mire of a wet street, and everything was sure to be splattered with mud by passing horses. The wild hogs that roamed the town literally used the streets as wallows.

In dry weather, the passing cattle herds would raise a cloud of dust as they lumbered down the Shawnee Cattle Trail to the stockyards. It was so bad that residents knew when a herd was advancing on the city just by the swirl of dust that would form around the cattle.

Individual business owners along city streets tried to improve the conditions by building board sidewalks in front of their shops. This helped in keeping some of the mud or dust out of their place of business, but it really didn't solve the problem.

At one point, Campbell Russell, a cattle rancher, tried to drive home the point about the need for street improvements in Indian Territory towns. With a newspaper photographer on hand to snap his picture, the colorful cattleman sat on a camp stool on a boardwalk by the Texas Road.

A crowd of onlookers gathered around him while he baited an especially long cane fishing pole and cast it out into the standing water. Everyone got a good laugh from the gag, but the streets remained a problem until complaints turned into action.

ORGANIZING ASSOCIATIONS

Individuals in both territories joined the chorus of calls for improved road construction that became a national effort known as the Good Roads Movement. This movement started among bicyclists in the eastern cities who wanted a better surface than dirt or gravel to ride on. The League of American Wheelmen (LAW) was part of the bicycle craze that swept through cities across America in the 1890s.

This organization began publishing the *Good Roads* magazine in 1892, advocating for better road construction for cyclists. But it also gained allies among farmers and the railroads that wanted to ship the farmers' produce.

Truck farms, abundant in the river bottom lands along the Katy Railroad, needed good roads to get produce to market. *From Library of Congress, WPA Collection.*

There was likely not a great deal of bicycle use in Oklahoma due, in part, to the rural nature of the territories and the lack of cities with paved streets. But there were many farmers, and at their Grange meetings across Oklahoma, better roads were a prominent and persistent issue.

In 1893, a National Good Roads Association was organized and headquartered in St. Louis. That same year, the U.S. Department of Agriculture created the Office of Road Inquiry with the goal of benefiting farmers through a systematic evaluation of existing roads. In 1905, this entity became the Office of Public Roads.

The first road association in Oklahoma began in 1902, and by 1904, it had grown to become the Oklahoma–Indian Territory Good Roads Association. It had the support of the various rail lines through the territories. Rail officials knew their six thousand miles of line would benefit if customers and vendors had better access to them along passable roads. The St. Louis & San Francisco Railroad (the Frisco) actually built sections of demonstration roads in various locations across the territories.

In 1906, the association changed its name to the Oklahoma Good Roads Association, and Sidney Suggs of Ardmore in the Chickasaw Nation served as its president. Many smaller town associations were also active at this time, including several along the Texas Road.

Muskogee was heavily involved in the Good Roads Movement. The unofficial capital of Indian Territory hosted the annual meeting of the National Good Roads Association in December 1906, held jointly with the Oklahoma Association. Muskogee's own Charles N. Haskell was elected to the executive board of the national association. Muskogee's postmistress at the time, Alice Robertson, spoke at the meeting. The future congresswoman advocated for better roads to help farm women

Early roads were often simply graded and compacted dirt running parallel to the railroad. *Oklahoma Historical Society.*

who suffered depression and other mental health problems from the isolation of inaccessible farms.

In 1909, Oklahoma's legislature gave counties the authority to create road improvement districts. Sidney Suggs assumed the role of first commissioner for the Oklahoma Highway Department when it was established in 1911. Suggs made a tour of the state by horse and buggy, talking up support for better roads. His motto was "A good road for tire and hoof."

By this time, the tires of automobiles and trucks were rapidly replacing the horse, buggy and farm wagon. In Muskogee, Homer Spaulding was the first person to own one of these new modes of transportation. Spaulding's auto was called a White Steamer, possibly one manufactured by the Stanley Steamer Company.

Spaulding was proud of his auto and liked spinning around town to show it off. He once drove it to a picnic being held on the bank of the Arkansas River east of town. When Spaulding prepared to drive home, the car got stuck in reverse and almost landed him in the river. Spaulding had to back the car all the way home. Perhaps this incident helped spur his interest in bridge building.

At first, the state of Oklahoma had few laws regulating traffic and did not require license tags for vehicles. It was left to cities to deal with these matters.

Towns such as Vinita built brick streets to accommodate the increasing number of automobiles. *Oklahoma Historical Society.*

Towns were passing speed limit laws within their jurisdictions as early as 1906. Generally, ten miles an hour was the maximum speed allowed. Many towns required automobiles to be tagged and owners to pay a licensing fee.

Oklahoma didn't start tagging cars until 1915, and the licenses included the year of issue. The tags had blue lettering on a white background. Later, tags carried a county identifier determined by population. When Oklahoma began issuing license tags, the cities ceased their licensing requirements. But some mandated all automobile owners to register their license numbers with the police.

Though crude compared to roads of today, the improvements brought about by the Good Roads Movement greatly improved rural life in Oklahoma. Farmers had much better access to town and railroad markets, businesses in town gained more farmers as customers and the value of property now accessible by road increased. The economy continued to be tied to the road.

Public and private cooperation was the keystone in the construction of better roads. When Muskogee again hosted a national meeting in 1907—the Trans-Mississippi Congress—better roads and river navigation were two important topics discussed. The commercial organizations that made up the Congress, as well as the many politicians who attended, all agreed that the western states needed to work cooperatively at creating better transportation for economic benefit.

Business owners, civic organizations, commercial clubs and chambers of commerce were all part of building better roads in Oklahoma. Promotion of travel included sociability runs between towns and challenges to distance speed records. Still, many of the roads remained graded gravel or dirt, and with increased use, they deteriorated rapidly and required ever-increasing

maintenance. People began to favor taxation by government entities to help ensure that their roads were passable.

One of the first cross-country projects growing out of the Good Roads Movement was the Lincoln Highway. This connection between New York and San Francisco began in 1912 and was quickly dubbed the "Main Street of America." The highway relied heavily on private investment but also revealed the need for federal involvement in road construction. As a memorial to President Abraham Lincoln, the highway served as a model and a spur for other paved transcontinental highways.

Improved methods of road construction accompanied new developments in the automobile along with its mass production. Soon, other visionaries were planning additional multi-state roads. Oklahomans joined such efforts and became members of the Ozark Trails Association, the Meridian Highway Association and the Jefferson Highway Association.

THE JEFFERSON HIGHWAY

ORGANIZING A HIGHWAY

In late 1913, Henry Ford began producing his Model T on the assembly line. This brought the price of a car down to about $300 and put it within almost everyone's reach. Now, Americans were able to travel like never before. The Good Roads Movement found new impetus with the advent of the affordable Model T.

Edwin T. Meredith was editor of *Successful Farming* and *Better Homes and Gardens* magazines, which were published in Des Moines, Iowa. The Lincoln Highway ran through that state, and its economic benefit to the region was readily apparent. Meredith, a passionate advocate for farmers, proposed the formation of a new north–south highway to run through the states that were part of the Louisiana Purchase. In 1915, he used the platform of his publications to drum up interest in this project.

Following the Lincoln Highway example, Meredith thought his proposed road should be named for another U.S. president, Thomas Jefferson. It was Jefferson who had concluded the "greatest real estate deal in history" with the Louisiana Purchase in 1803. With the stroke of a pen, the deal doubled the size of the United States.

In response to Meredith's challenge, the New Orleans Association of Commerce issued a call to the states making up the Louisiana Purchase to meet in New Orleans in November 1915 to discuss such a highway. Conference organizers expected about fifty attendees, but nearly six times

that many arrived at the host city. Oklahoma alone sent fifty delegates. David N. Fink, president of the Commercial National Bank of Muskogee, attended as a delegate from the youngest state.

Fink was an enthusiastic supporter of the Jefferson Highway. He quickly became the leader and spokesperson for the Oklahoma and Texas delegations. With the skilled leadership of former senator Lafayette Young of Des Moines, the convention in New Orleans ironed out the major points that had to be decided on before any highway development could begin.

A Jefferson Highway Association (JHA) was formed, and Edwin Meredith was elected president. David Fink became vice-president. The beginning and ending points of the road were also settled at this time. The Jefferson Highway was to run from New Orleans to Winnipeg, Manitoba, in Canada. The Jefferson would be an international highway. Headquarters for the association were settled at St. Joseph, Missouri, which was roughly halfway between the two terminus cities and at the northern end of the old frontier military road.

The highway was to be built with both private and government funds. Members of the Jefferson Highway Association paid a membership fee. The larger cities along the route would be assessed $100 each, and the delegates from those cities were responsible for raising those funds. Each county through which the road passed would be asked to contribute $9 per mile of road in that county.

At the New Orleans convention, $2,500 was raised immediately. Meredith gave $1,000, and Fink gave $500. Another Des Moines backer named H.H. Polk gave the other $1,000. It is little wonder that the route of the Jefferson Highway ran through Des Moines and Muskogee.

Fink also offered to set up an account for the Jefferson Highway Association at his bank in his hometown. Thus, Oklahoma leaders became major driving forces in developing the Jefferson Highway.

Subsequent meetings at St. Joseph were needed to hammer out the full route that the road would take. There were fifteen states carved from the Louisiana Purchase, but it was obvious that the highway could not reasonably meander through all fifteen states.

The most direct route from New Orleans to Winnipeg would have taken the road through western Arkansas. But the same factors that kept the old military road from being built along the Arkansas border still existed. The beautiful mountains of the Ouachitas and Ozarks made highway construction difficult. In 1915, western Arkansas had few paved roads.

The better choice, the Oklahoma delegation argued, would be to follow the well-marked and long-used Texas Road through the Indian Nations. This would require the road to veer into Texas, which had not actually been part of the Louisiana Purchase. But then, neither had Winnipeg.

In the end, the route was chosen based largely on where established roads within the various states already existed. The main cities along this highway were to be New Orleans, Baton Rouge, Denison, Muskogee, Joplin, Kansas City, St. Joseph, Des Moines, St. Paul and Winnipeg.

In Oklahoma, the delegates who had attended

This mileage marker in Muskogee's Spaulding Park shows the distances to the principal towns along the Jefferson Highway in 1923. *Author's collection.*

the New Orleans convention called a meeting of their own of towns along the Texas Road. They met in McAlester and organized the Oklahoma State Jefferson Highway Association. Paul Nesbitt, a future state representative for Pittsburg County, served as president of the Oklahoma chapter. Nesbitt would be heavily involved in the highway's development in Oklahoma.

With David Fink's enthusiasm in the lead, the nine counties to be traversed by the new international highway set to work to survey and mark the alignment, raise money through bond sales, put the construction work out to bid and begin their portion of this "miracle of cooperation and enterprise."

Public sentiment was high in favor of the "365-day" highway in Oklahoma. The Oklahoma Highway Commission was equally supportive of the Jefferson Highway project. Sidney Suggs declared the Jefferson "Main Line #5" for Oklahoma, with a route that would run from the state line north of Miami through Vinita, Pryor, Wagoner, Muskogee, Checotah, Eufaula, McAlester, Atoka and Durant to the Red River north of Denison.

Road construction was a challenge for the young state, not just in developing the expertise among engineers and workers, but also due to landownership. The old Texas Road had run for a couple of centuries in a relatively straightforward manner from the northeast corner of the Quapaw Nation in a southwesterly angle to the Chickasaw Nation.

There had been few fences along the whole route, and streams were crossed by ferries or toll bridges operated by private individuals. But following the land allotments, the whole dynamic of landownership and road usage changed. Fences now blocked sections of the road traversing land no longer held for common use by the tribes.

To accommodate these conditions, the state required that surveyed section lines remain open and unfenced for roads. Thus, the route of the Jefferson required travelers to zigzag constantly in more heavily populated areas and towns, changing directions at ninety-degree angles every mile. Today, the angles of the road's old alignment have been smoothed into curves that make for an enjoyable and far more interesting drive than the straightened four-lane sections of the road.

States received a big boost in road funding in 1916, when President Woodrow Wilson signed the Federal Aid Road Act. This piece of legislation offered matching funds to states for road projects approved by the Bureau of Public Roads. In addition, the state legislature approved a matching funds grant

The Jefferson Highway Bridge north of Muskogee is one of only a few metal-trussed bridges remaining on the old alignment of the highway. *Author's collection.*

program for the counties. With over $690,000 coming to Oklahoma in the following two years, hundreds of road projects were soon underway. Many of those approved projects were for bridges along the Jefferson Highway route.

Construction continued at a steady pace throughout 1916 but was slowed the following year when America entered the world war. Manpower and materials were diverted to war industries and the military.

Oklahoma turned to convict labor for some bridge work, employing the prisoners housed at the state penitentiary in McAlester. Supervised by construction contractors, these men were said to have done excellent work in building several stone and concrete arched bridges along the Jefferson Highway. Steel for trusses was in short supply, making the stone bridges a necessity. Some of these old bridges can still be found along old alignments of the highway.

Work resumed after the war, though it took some time for the country to switch back to civilian endeavors. For the next decade, construction was happening somewhere along the highway at all times. Gradually, graded dirt and gravel gave way to macadam pavement. The one-time trail for buffalo and cattle was becoming a long ribbon of asphalt through the Indian lands.

SOCIABILITY

Even without bridges being completed, the highway was being used and touted for its quality as early as the spring of 1916. Newspapers in towns along the route kept their readers abreast of every nuance of road developments from the moment Oklahoma secured the route to every stretch of highway completed within a county to every fundraising effort undertaken.

J.D. Clarkson of Carthage, Missouri, had been hired as general manager for the Jefferson Highway. The *Muskogee Times-Democrat* announced in its April 20, 1916 issue that Clarkson would tour the Jefferson Highway south from Carthage and travel through Oklahoma, Texas and Louisiana to New Orleans. The *Caddo Herald* reported in August 1916 that the Jefferson Highway had been completed south of town to the Bryan County line, with two new bridges under construction.

The year 1916 was one of tremendous activity on the new highway that followed the route of the very old road in Oklahoma, often running exactly parallel to the Katy Railroad. Sociability runs were undertaken that year all along the Jefferson. Especially of interest was a relay caravan of over five

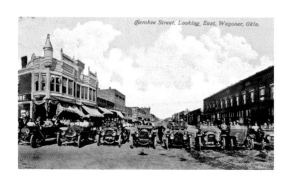

Autos line the Jefferson Highway in Wagoner, possibly for a sociability run. *Author's collection*.

hundred cars from St. Joseph to Winnipeg, with the various towns along the route participating.

One purpose of these sociability drives was to advertise the road and encourage cooperation in construction and fundraising efforts. It was noted by many newspapers that the road was fostering better relations between neighboring towns, states and nations. The isolation that had been the lot of most rural homes and communities was being replaced with a new sense of connection, camaraderie and understanding.

David Fink often reported to the Muskogee newspapers about his drives along the highway as he traveled from community to community to facilitate road construction. He reported in 1916 that he and his family had traveled from Muskogee to Joplin, Missouri, a distance of 149 miles, in "just seven hours."

The Jefferson Highway Association held its second annual meeting at the Severs Hotel in Muskogee, no doubt at the invitation of its vice-president. Many members of the association drove to the meeting, waving signs, banners and American flags all along the way. At this meeting, Manager Clarkson reported that fully one-quarter of the highway had already been completed. David Fink was elected the JHA's second president, succeeding Edwin Meredith. For Oklahomans, Fink became the "father of the Jefferson Highway."

In a concurrent meeting of the Oklahoma chapter, Fink proposed the construction of a new bridge over the Canadian River at Eufaula to replace an existing toll bridge. A nonprofit organization was formed to manage the project and raise the $125,000 needed for it. But this proved to be the only easy part of actually getting the bridge built.

When America declared war on Germany and entered the great global conflict, our nation joined neighboring Canada, which had already been in the fight for a year. In a show of gratitude and international goodwill, an

entourage of Manitoba officials made a sociability run in 1917 all the way to New Orleans on the Jefferson. Included in the group were the Manitoba premier T.C. Norris and Frederick Davidson, the mayor of Winnipeg.

Three cars made the entire 2,300-mile trip to New Orleans, but other cars joined in the drive for ten to as many as 250 miles. In total, it was estimated that four thousand cars participated at some point along the highway.

All along the route, Premier Norris was asked to speak about the war, and he offered words of gratitude and calls for courage and commitment at each stop. While some northerners had wondered about the conditions of roads in Oklahoma, the wayfarers found they were not slowed at all through the youngest state on the route.

In 1918, the JHA annual meeting was held in Joplin. A sociability run from Denison to Joplin was planned by David Fink. Scheduled for the Fourth of July, the run became a patriotic parade and a rousing endorsement of this good road through Oklahoma. Fink gave credit to the Jefferson for the improvement of all roads within the counties through which the highway passed.

THE BRIDGE WARS

Paving the Jefferson in Oklahoma was one of the easier parts of creating a modern highway. In many sections, the road had been used for years and was rock hard from thousands of hooves and wheels passing over it. The roadbed needed only a little work to be ready for the macadam or crushed gravel used to pave it.

The bridges were another matter and proved much more challenging—and not just from a construction standpoint. Toll bridges or ferries had long operated over the Grand, Verdigris, Arkansas, Canadian and Red Rivers. When new bridges were proposed for the Jefferson Highway, the livelihood of ferry and bridge operators was threatened. The counties or state, therefore, not only had to fund the construction of the new bridge but also had to buy out the private operators.

The exact location of the bridge also became an issue of contention for the Canadian River crossing. In fact, disputes over the location held up completion of the Jefferson in Oklahoma. The Canadian River served as the boundary line between McIntosh and Pittsburg Counties. Both counties would bear the cost of construction. For more than a year, county officials wrangled over costs and the location for the bridge.

Finally, the matter came to a head in the spring of 1917. J.D. Clarkson called for a meeting with McIntosh and Pittsburg County leaders in McAlester. Attending from Eufaula were Cornelius Foley, C.W. Gust and G.J. Fuller. The McAlester delegates were J.D. Jones, R.P. Brewer and Fred Russell. President Fink also rode the Katy train down to McAlester for the gathering.

Clarkson pulled no punches in the meeting. He told both parties to "shoot or give up your gun." If they could not reach an agreement in this meeting, he warned, then the road would be moved out of their counties. It was no idle threat.

Still the arguments continued all afternoon. Finally, in a crafty move, Foley made an offer. He said the people of Eufaula would raise $15,000 for the bridge if Pittsburg County would raise another $60,000. If McAlester did so, then they could choose the bridge location.

The McAlester men bristled at the inequitable funding offer. Then Mr. Gust said, "Then turn it around. You raise $15,000, and we'll raise the $60,000 and we choose the bridge site."

"We'll do it," Fred Russell agreed. And so, in a moment, the deal was struck. Within ten minutes, a contract had been drawn up and signed, and

The Foley Building still stands in Eufaula, a town so influenced by Cornelius Foley that it was sometimes called Eu"foley." *Author's collection.*

a deadline of noon the next day was given to Eufaula to gather pledges of the needed funds.

Eufaula met its deadline, and Pittsburg County had its funds committed by the following day. The state would match the $75,000, to bring the total cost of the bridge and buyout to $150,000. The Canadian River Bridge was slowed by the war but fully completed by 1920. It was considered one of Oklahoma's most impressive structures, a nearly half-mile-long series of steel trusses and concrete piers that had to be dug fifty feet down to bedrock.

For another decade, the bridge over the Red River for the Jefferson Highway continued as a toll bridge. In fact, a number of toll bridges crossed the Red, tapping into the rich oilfield work in Oklahoma and Texas.

The Jefferson Highway bridge near Colbert had its beginnings as a ferry operation run by the town's namesake. Benjamin Colbert, who had married a Chickasaw woman, had permission from the tribe to operate the ferry and did so for many years. It was used by the Butterfield Stage Line on its run into Texas.

Colbert sold his interest in the ferry to the Red River Bridge Company, which built the toll bridge in 1892. This bridge was replaced in 1915 as the JHA was getting organized. It continued to funnel traffic into Texas until 1931.

In that year, the highway departments of Texas and Oklahoma cooperated in building a free bridge a short distance from the toll crossing. The Red River Bridge Company was to be compensated for its bridge when the new one was completed. The free bridge opened, but the Red River Bridge Company had not been paid.

It filed an injunction in a Houston court to halt the opening of the free bridge, and the injunction was granted. Texas highway workers put up barricades on the south end to keep traffic from using the bridge.

However, Oklahoma's flamboyant governor William "Alfalfa Bill" Murray ordered the bridge opened and the barricades torn down. A standoff between the two states began, and telegrams flew back and forth between Murray and Texas governor Ross Sterling. Murray rightly claimed that the bridge lay within Oklahoma because the south bank of the river was the boundary line between the states as set forth in the Louisiana Purchase treaty.

Sterling sent Texas Rangers to the bridge. Murray responded by sending the Oklahoma National Guard to close the approach to the toll bridge. No one could cross either bridge while the standoff continued. Angry crowds gathered in Texas demanding bridge access.

The Texas legislature intervened and cleared the way for the toll bridge company to receive its compensation. The injunction ended, and both bridges

were opened to traffic. The toll bridge was closed permanently and demolished sometime later, and the new Highway 69 bridge connected Denison to Durant once again. Oklahomans declared that their state had won the war with Texas.

THE FEDERAL SYSTEM

In 1924, the Oklahoma legislature created a State Highway System under the management of a three-member highway commission. The commission designated three types of roads: township, county and state. The state highways were assigned numbers, and the Jefferson became Highway 6 out of twenty-six highways across the state. By 1925, all of these highways had been completed, though to varying degrees of quality.

That same year, the secretary of agriculture established a board made up of state and federal highway officials. Its mandate was to develop a federal system of highways with uniform signage. The National Highway System was finalized and approved in 1926. In that year, another interstate was begun and given the Highway designation of 66. In northeastern Oklahoma, Highway 66 used an existing length of the Jefferson from Vinita to Baxter Springs, Kansas.

All forty-eight states soon adopted the uniform numbering of those roads now designated as federal highways. The Jefferson in Oklahoma was given the number 73 but was renumbered as Highway 69 in the 1930s.

Civilian traffic was restricted somewhat during World War II, but military installations along the route made up for it. Munitions plants near Savanna and Pryor Creek and a training base called Camp Gruber near Muskogee utilized the Jefferson in the war effort.

The Federal Highway Act of 1956 brought a final major change to the Jefferson Highway. President Dwight Eisenhower envisioned a national system of superhighways that would be important to national defense but would also facilitate the transport of all goods and provide ease and speed for travelers.

The old Jefferson Highway alignment with its zigzag pattern was straightened and widened. In many cases, it was moved out of the downtowns of communities along the route to the edges of town. In some instances, it bypassed those towns altogether.

Highway 69 has become a major truck route through Oklahoma with a massive tonnage of goods moved through the state every day. One of the state's busiest highways today, Route 69 continues the legacy of the very old road with roots deep in the history of Oklahoma.

THE DRIVE IS FINE

A TOURIST'S DELIGHT

It doesn't matter how wide or straight Highway 69 has become, lying just beneath its ribbon of asphalt and concrete is a remarkable history. So much of the original alignment exists today that observant travelers along this road can still touch that history. The drive is fine on Route 69, and a run along its length in Oklahoma gives tourists a true taste of the past.

In fact, the many sociability runs undertaken in the early days of the Jefferson Highway served to highlight this part of the vision for the road. It was intended to be a "tourist's delight" all the way from the pines of Canada to the palm trees along the Gulf.

To mark the route for tourists, the JHA followed the Lincoln Highway's example. The Jefferson Highway logo was very similar to the Lincoln's. It included a large white field with the letters "JH" juxtaposed on each other in black. The white field was banded with a blue stripe on top and bottom. These JH signs were painted or mounted on locations all along the 2,300 miles of highway. Additional signs alerted drivers of upcoming turns, dangerous intersections and railroad crossings.

Most of the highway markings were made through the private endeavors of Jefferson Highway Associations in the various states. The JHA did everything it could to make the driving experience easy and pleasurable. In 1923, there were over two thousand metal signs in place

Dubbed the "Pine to Palm Highway," the Jefferson ran from Winnipeg to New Orleans and was marked with thousands of signs along the route. *Author's collection*.

The Kiwanis Tourist Camp could accommodate two hundred cars and is still used today at Muskogee's Spaulding Park. *Author's collection*.

along the Pine to Palm route. There were an additional twenty thousand pole markers and JH monograms on buildings, barns and bridges.

The JHA also published an *International Tourist Guide* in the 1920s, giving vacationers valuable information about amenities along the road. Many communities on the Jefferson in Oklahoma had tourist camps that could accommodate up to two hundred cars a day.

Long before the "motor court," or "motel," came into existence, tourists would simply camp alongside the road when traveling. The tourist camp was a designated location within a community where travelers could picnic, cook a meal, use the restroom and, in some cases, even take a shower. Many a Model T pulled into these facilities at Miami, Pryor Creek, Muskogee, Eufaula and McAlester, grateful for a safe respite from the road.

Today, the only known tourist camp still in existence is found in Muskogee's Spaulding Park. It was built by the local Kiwanis Club in 1921, with a fully enclosed building housing cookstoves, restrooms and showers. This old campground facility is still utilized by groups today, and it makes a great stop for current travelers on the Jefferson.

HAVE SOME FUN

There are still locations in Oklahoma where the ruts of the old Texas Road are visible, such as the Honey Springs Battlefield near Rentiesville. Many of the old river bridges have been replaced, but one steel-trussed crossway still stands between Muskogee and Okay. A section of the Red River toll bridge is located in Colbert's city park.

Plenty of quirky sights and signs will greet the traveler who cares to take the old alignment that still exists across the state. Often, the Jefferson Highway is marked as Business 69, Alternate 69 or Old Highway 69 and will take visitors through the downtowns of many communities along the way. Antique malls, diners, themed motels, vintage gas stations and dozens of "mom and pop" businesses tempt the traveler to stop and stay for a while.

Tourists can experience the history and culture of what once was Indian Territory at a number of museums and historical sites along the route. Battlefields, cemeteries, cultural centers and ethnic eateries all await the traveler who enjoys the slower pace of the old two-lane roads that don't bypass the real Oklahoma.

"Photo ops" are plentiful as well. Pose with Tall Chief at Big Cabin or the mileage marker at Muskogee's Spaulding Park or any number of other fun locations along the way. There are beautiful murals in nearly every community on the route, but Wagoner, McAlester and Vinita offer some of the best. Old Katy Railroad depots house local museums at Checotah and Pryor Creek.

Some highways have gained nicknames over the years. The Lincoln Highway was dubbed "America's Main Street." John Steinbeck called

Tall Chief towers over the Love Travel Stop near Big Cabin on Highway 69. *Author's collection.*

Route 66 the "mother road." But for a road that stretches back for over two centuries as the Jefferson does in Oklahoma, it surely must be called the "granddaddy road." All of the old traces and trails have their history, but few can claim such a varied and vivid tale as that told by Route 69 and all its predecessors.

"The Drive Is Fine"

The drive is fine
From Palm tree to Pine;
Rolling through the sunshine;
Cruising down the line.

The drive is fine
On Route 69
You can have some fun
On the Jefferson!

This "cowboy" plays an eight-foot guitar on an
original section of the Jefferson Highway in Muskogee.
Author's collection.

BIBLIOGRAPHY

Account of the Gold Rush Over the Southern Route. Norman: University of Oklahoma Press, 1968.

"All-Black Towns of Oklahoma." Tulsa Historical Society & Museum. http://tulsahistory.org/learn/past-exhibits/all-black-towns-of-oklahoma.

Barry, Louise. "The Fort Leavenworth-Fort Gibson Military Road and the Founding of Fort Scott." *Kansas Historical Society* 11, no. 2 (May 1942).

"Battle of Middle Boggy." Civil War Album. http://www.civilwaralbum.com/atoka/battle.htm.

Benefield, Glenda Wilson. "Stringtown." Encyclopedia of Oklahoma History and Culture. http://www.okhistory.org.

"A Brief History of the City of St. Louis." St. Louis, Missouri. http://www.stlouis-mo.gov/visit-play/stlouis-history.cfm.

Burns, Louis F. "Osage (Tribe)." Encyclopedia of Oklahoma History and Culture. http://www.okhistory.org.

Burton, Art T. "African-American Soldiers at Fort Gibson." *3 Rivers Historian* 2, no. 2 (Spring 1999).

"Cabin Creek Battlefield." Civil War Trust. http://www.civilwar.org/civil-war-discovery-trail/sites/cabin-creek-battlefield.html?referrer=https://www.google.com.

Cassity, Michael. "Route 66." Encyclopedia of Oklahoma History and Culture. http://www.okhistory.org.

Cox, Matthew Rex. "Atoka Agreement." Encyclopedia of Oklahoma History and Culture. http://www.okhistory.org.

BIBLIOGRAPHY

Dary, David. "Cattle Drives." Encyclopedia of Oklahoma History and Culture. http://www.okhistory.org.

"A Dispute of Years Settled." *Jefferson Highway Declaration* 2, no. 2 (March 1917).

Dott, Robert H. "Lieutenant Simpson's California Road Across Oklahoma." *Chronicles of Oklahoma* 38, no. 2 (Summer 1960).

Epple, Jess. *Honey Springs Depot.* Muskogee, OK: Hoffman Printing, 1964

Everett, Dianna. "Good Roads Association." Encyclopedia of Oklahoma History and Culture. http://www.okhistory.org.

———. "Highways." Encyclopedia of Oklahoma History and Culture. http://www.okhistory.org.

Faulk, Odie. *Muskogee: City and County.* Muskogee, OK: Five Civilized Tribes Museum, 1982.

Fly, Shelby M. *The Saga of the Chouteaus in Oklahoma.* The Land We Belong to Is Grand pamphlet series, n.d.

Foreman, Grant. "Fort Davis." *Chronicles of Oklahoma* 17, no. 2 (June 1939).

———. *Down the Texas Road: Historic Places Along Highway 69 Through Oklahoma.* Norman: University of Oklahoma Press, 1936.

———. *Marcy and the Gold Seekers: The Journal of Captain R.B. Marcy, with an*

———. *Muskogee: Biography of an Oklahoma Town.* Norman: University of Oklahoma Press, 1943

Foreman, Grant, and Carolyn Foreman. *Fort Gibson: A Brief History.* Muskogee, OK: Hoffman Printing, n.d.

"Fort Smith History." National Park Service. http://www.fortsmithhistory. com/archive/chronology.html; nps.gov/fortsmith.

Franzmann, Tom. "Indian Home Guard." Encyclopedia of Oklahoma History and Culture. http://www.okhistory.org.

Gard, Wayne. "The Shawnee Trail." *Southwestern Historical Quarterly* 56 (January 1953).

Garrison, Tim A. "Cherokee Removal." New Georgia Encyclopedia, September 2015.

"Good Road to Caney." *Caddo Herald,* August 4, 1916

Goostree, Eric. "Mining Towns." Encyclopedia of Oklahoma History and Culture. http://www.okhistory.org.

"The Great Cattle Drives: Frontier Life in Oklahoma 1866–1889." HubPages, updated on July 18, 2011. http://hubpages.com/travel/OklahomaGreatCattleDrives#.

Guinn, Jeff. *Go Down Together: The True, Untold Story of Bonnie and Clyde.* New York: Simon & Schuster, 2010.

Hamilton, Ann. *Oklahoma Almanac.* N.p.: Oklahoma Department of Libraries, 1955.

Harlan, Edgar. *Annals of Iowa* 16, no. 6 (October 1928).

BIBLIOGRAPHY

Heck, Jess. "Miami (Town)." Encyclopedia of Oklahoma History and Culture. http://www.okhistory.org.

Historical Quarterly 13, no. 7 (August 1945).

"History—Broad Range of Authority." U.S. Marshals Service. http://www.usmarshals.gov/history/broad_range.htm.

"History of McAlester." City of McAlester. http://www.cityofmcalester.com/index.aspx?nid=130.

Hoagland, Bruce W. "Cross Timbers." Encyclopedia of Oklahoma History and Culture. http://www.okhistory.org.

Kelly, Susan Croce. "Good Road Movement." Britannica. http://www.Britannica.com.

Kidwell, Clara Sue. "The Effects of Removal on American Indian Tribes." National Humanities Center. http://nationalhumanitiescenter.org/tserve/nattrans/ntecoindian/essays/indianremovald.htm.

Lovett, John R. "Major Cattle Trails, 1866–1889." *Historical Atlas of Oklahoma*, n.d.

Masterson, V.V. *The Katy Railroad and the Last Frontier*. Columbia: University of Missouri Press, 1952.

Matthews, C. Allen, and Frank D. Wood. "Picher." Encyclopedia of Oklahoma History and Culture. http://www.okhistory.org.

McCoy, Joseph G. *Historic Sketches of the Cattle Trade of the West and Southwest*. Kansas City, KS: Ramsey, Millett and Hudson, 1874.

McDermott, John Francis, ed. "Isaac McCoy's Second Exploring Trip in 1828." *Kansas Historical Quarterly* 13, no. 7 (August 1945).

"Meetings." *Good Roads Magazine* 8 (January–December 1907).

Meredith, Howard. "Caddo (Kadohadacho)." Encyclopedia of Oklahoma History and Culture. http://www.okhistory.org.

Messer, Carroll. "Battle of Middle Boggy: Phillips Expedition of February 1864 into Indian Territory." Seminole Nation. http://www.seminolenation-indianterritory.org/cwmiddleboggybattle.htm.

Milligan, James C. "Colbert." Encyclopedia of Oklahoma History and Culture. http://www.okhistory.org.

"Missouri-Kansas-Texas Railroad." Texas State Historical Society. https://tshaonline.org/handbook/online/articles/eqm08.

Mize, Richard. "Sequoyah Convention." Encyclopedia of Oklahoma History and Culture. http://www.okhistory.org.

"The Mound Builders." National Park Service. http://www.nps.gov/nr/travel/mounds/builders.htm.

Mullins, Jonita. "Albert Pike Convinced Tribes to Join the South." *Muskogee Phoenix*, July 22, 2007.

———. "Al Jennings Captured Near Onapa." *Muskogee Phoenix*, November 9, 2009.

————. "Bonneville's Adventures Made Him Famous." *Muskogee Phoenix*, April 3, 2011.

————. "Cotton Queen Promoted Major Area Crop." *Muskogee Phoenix*, April 29, 2012.

————. "Dawes Commission Aimed to Bring Tribes to Statehood." *Muskogee Phoenix*, October 21, 2007.

————. "Edwards' Settlement Was a Crossroads for Travel and Trade." *Muskogee Phoenix*, June 17, 2007.

————. "End of Civil War Was Slow to Come to Indian Territory." *Muskogee Phoenix*, July 29, 2007.

————. "Five Tribes Were Deemed Civilized by 1840s." *Muskogee Phoenix*, June 24, 2007.

————. "Fort Gibson Was Frontier's Westernmost Garrison." *Muskogee Phoenix*, May 20, 2007.

————. *Glimpses of Our Past*. Muskogee, OK: Jonita Mullins, 2014.

————. "Golden Age for Five Tribes Saw Many Churches and Schools Built." *Muskogee Phoenix*, July 1, 2007.

————. "The Gold Rush Brought a Stampede Across Oklahoma." *Muskogee Phoenix*, July 22, 2007.

————. "Horseless Buggies Made City Streets a Challenge." *Muskogee Phoenix*, September 19, 2004.

————. "Jefferson Highway among Earliest Interstate Roads." *Muskogee Phoenix*, May 30, 2004.

————. *Journey to an Untamed Land*. Muskogee, OK: Jonita Mullins, 2014.

————. *Life Along the Rivers*. Muskogee, OK: Jonita Mullins, 2015.

————. "Liveries Were Successful Early Businesses." *Muskogee Phoenix*, November 23, 2008.

————. "Many Forms of Transportation Moved Muskogee." *Muskogee Phoenix*, October 6, 2013.

————. "Muskogee Turns 140 Years Old Today." *Muskogee Phoenix*, January 1, 2012.

————. "Several State Conventions Were Held Before Statehood." *Muskogee Phoenix*, November 4, 2007.

————. "Special Interests Wrangled Over Oklahoma Lands." *Muskogee Phoenix*, October 7, 2007.

————. "Statehood Brought Ceremony and Sorrow." *Muskogee Phoenix*, November 11, 2007.

————. "Supply Line to Fort Was Focus of Battles." *Muskogee Phoenix*, February 21, 2016.

————. "Towns Battled Dust and Mud in What Passed for Streets." *Muskogee Phoenix*, March 27, 2005.

———. "Train Robbery Brought Famous Outlaw and Lawmen Together." *Muskogee Phoenix*, October 25, 2009.

———. "Treaties Brought Civil War to Tribes." *Muskogee Phoenix*, April 24, 2005.

———. "U.S. Marshals Played an Important Role in Area History." *Muskogee Phoenix*, September 20, 2009.

———. "Washington Visit Found Thriving Black Businesses in Muskogee." *Muskogee Phoenix*, July 4, 2010.

"Muskogee (Creek) Nation History." Muscogee Nation. http://www.muscogeenation- nsn.gov/Pages/History/history.html.

Muskogee Times-Democrat. "Road Booster to Live on the Road." April 20, 1916.

———. "Sociability Run Will Be Big Motor Event." June 15, 1918.

O'Dell, Larry. "All-Black Towns." Encyclopedia of Oklahoma History and Culture. http://www.okhistory.org.

Okamura, Ryoko. "California Road." *Encyclopedia of Oklahoma History and Culture.* http://www.okhistory.org.

Phillips, John Neal. *Running with Bonnie & Clyde: The Ten Fast Years of Ralph Fults.* Norman: University of Oklahoma Press, 2002.

Sewell, Steven L. "Coal." Encyclopedia of Oklahoma History and Culture. http://www.okhistory.org.

Shannon, Daisy. "George Shannon." *Chronicles of Oklahoma* 10, no. 4 (December 1932).

Smith, Glen. "Muskogee and the Jefferson Highway." *Jefferson Highway Declaration* 2, no. 1 (Winter 2013).

"The State Road System and Federal Aid." Oklahoma Department of Transportation. http://www.okladot.state.ok.us/hqdiv/p-r-div/spansoftime/roadsystem.htm.

Tatro, M. Kaye. "Curtis Act (1898)." Encyclopedia of Oklahoma History and Culture. http://www.okhistory.org.

Taylor, Lonn W. "The Red River Bridge Controversy." Handbook of Texas. https://tshaonline.org/handbook/online/articles/mgr02.

Trickett, Dean. "The Civil War in the Indian Territory." *Chronicles of Oklahoma* 19, no. 1 (September 1939).

Veenendaal, Augustus J., Jr. "Railroads." Encyclopedia of Oklahoma History and Culture. http://www.okhistory.org.

"Wagoner County History." Oklahoma Genealogy. http://www.oklahomagenealogy.com/wagoner/wagoner-county-history.htm.

Wagoner, Jay J. *Oklahoma!* Oklahoma City, OK: Thunderbird Books, 1987.

Waits, Wally. "Early Motoring in Muskogee." *3 Rivers Historian* 2, no. 1 (Winter 1999).

Ward, Mary Jane. *George Washington Grayson and the Creek Nation.* Norman: University of Oklahoma Press, 1999.

BIBLIOGRAPHY

Weaver, Bobby D. "Texas Road." Encyclopedia of Oklahoma History and Culture. http://www.okhistory.org.

West, C.W. "Dub." *Missions and Missionaries of Oklahoma*. Muskogee, OK: Thomason Printing Company, 1990.

———. *Muskogee, I.T.: The Queen City of the Southwest*. Muskogee, OK: Muscogee Publishing Company, 1972.

———. *Turning Back the Clock*. Muskogee, OK: Muscogee Publishing Company, 1980.

Wikipedia. "Battle of Cabin Creek." Last updated May 31, 2016. https://en.wikipedia.org/wiki/Battle_of_Cabin_Creek.

———. "Red River Bridge War." Last updated May 13, 2016. https://en.wikipedia.org/wiki/Red_River_Bridge_War.

Wilson, Linda D. "Statehood Movement." Encyclopedia of Oklahoma History and Culture. http://www.okhistory.org.

Wright, Muriel. "Contributions of the Indian People to Oklahoma." Chronicles of Oklahoma 14, no. 2 (June 1936).

———. *Our Oklahoma*. Guthrie, OK: Co-operative Publishing Company, 1939.

———. "The Removal of the Choctaws to the Indian Territory, 1830–1833." *Chronicles of Oklahoma* 6, no. 2 (June 1928).

INDEX

INDEX

INDEX

ABOUT THE AUTHOR

Jonita Mullins grew up in the small town of Haskell, Oklahoma. After graduating from Haskell High School, she attended Oklahoma State University, earning a bachelor's degree in English.

She realized a dream when she purchased a historic home in Muskogee's Founders' Place Historical District. Keeping with her passion for history and its preservation, she volunteers with Muskogee's Neighborhood Alliance for Historic Preservation and with the Bass Reeves Legacy Troupe.

For several years, Jonita has written a weekly column on area history for the *Muskogee Phoenix* newspaper. With the *Phoenix*, she received the Distinguished Editorial Award from the Oklahoma Heritage Association.

Jonita has published a history of her hometown titled *Haskell: A Centennial Celebration*. Two nonfiction books—*Glimpses of our Past* and *Life Along the Rivers*—are collections of nearly two hundred of her *Phoenix* articles.

Her first novel, titled *Journey to an Untamed Land*, recounts the story of the first missionaries and schoolteachers in Oklahoma, who worked among

the Osages. Its sequel, *Look Unto the Fields*, continues the saga of this first missionary effort as the second book in the three-part series "The Missions of Indian Territory." All of Jonita's books can be purchased at her website ,okieheritage.com.

Jonita is a frequent speaker to church and civic clubs, schools and libraries, women's conferences, workshops, motivational seminars and heritage events. To book her for an event, she can be contacted through her website.